WORLD
FILM
LOCATIONS
GLASGOW

Edited by Nicola Balkind

T0345332

First Published in the UK in 2013 by
Intellect Books, The Mill, Parnall Road,
Fishponds, Bristol, BS16 3JG, UK

First Published in the USA in 2013
by Intellect Books, The University of
Chicago Press, 1427 E. 60th Street,
Chicago, IL 60637, USA

Copyright © 2013 Intellect Ltd

Cover photo: NEDs © 2010
Blue Light / The Kobal Collection

Copy Editor: Emma Rhys

All rights reserved. No part of this
publication may be reproduced, stored
in a retrieval system, or transmitted, in
any form or by any means, electronic,
mechanical, photocopying, recording,
or otherwise, without written consent.

A Catalogue record for this book is
available from the British Library

World Film Locations Series
ISSN: 2045-9009
eISSN: 2045-9017

World Film Locations Glasgow
ISBN: 978-1-84150-719-4
EISBN: 978-1-84150-746-0

Printed and bound by
Bell & Bain Limited, Glasgow

WORLD FILM LOCATIONS
GLASGOW

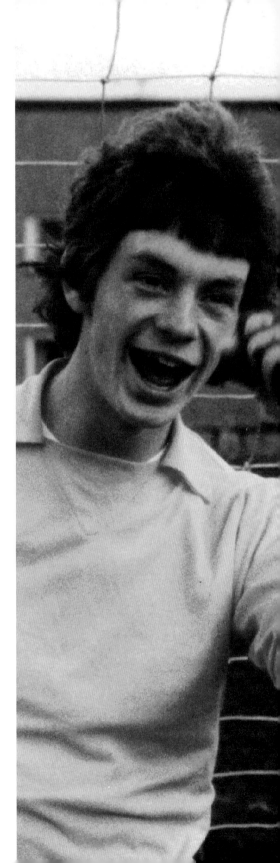

EDITOR
Nicola Balkind

SERIES EDITOR & DESIGN
Gabriel Solomons

CONTRIBUTORS
David Archibald, Jez Conolly,
Helen Cox , Jamie Dunn,
Paul Gallagher, Paul Greenwood,
Scott Jordan Harris, Keir Hind,
Linda Hutcheson, Pasquale Iannone,
Simon Kinnear, Neil Mitchell,
John Nugent, Susan Robinson,
Emma Simmonds, Lewis Smith,
Neil Johnson-Symington,
Matthew Turner, Sean Welsh,
Caroline Whelan

LOCATION PHOTOGRAPHY
Lewis Smith
(unless otherwise credited)

LOCATION MAPS
Joel Keightley

PUBLISHED BY
Intellect
The Mill, Parnall Road,
Fishponds, Bristol, BS16 3JG, UK
T: +44 (0) 117 9589910
F: +44 (0) 117 9589911
E: info@intellectbooks.com

Bookends: Kelvingrove Art Gallery and Museum
(Lewis Smith)
This page: *Gregory's Girl* (Kobal)
Overleaf: *Trainspotting* (Kobal)

CONTENTS

ACKNOWLEDGEMENTS

Hugest thanks to this book's many contributors and tireless photographers: friends and talents all, and without whom Glasgow's cinema may yet lay undiscovered. To Hamish Walker at Glasgow Film Office for his expertise, Nick and the Park Circus team for uncovering hidden gems, and everyone who answered our calls. Thanks to Gabriel, Scott, Neil, Jez and Intellect for leading me here. Thank you, David and Patricia, as ever for your pride and encouragement. And thank you, Evan Condry, for lending your eyes and unyielding support. Thanks, all. And thank you – yes, you – for reading.

NICOLA BALKIND

INTRODUCTION

World Film Locations Glasgow

DISSECTED AS IT IS by the River Clyde, Glasgow is certainly a city of meandering divisions. The shipyards to the south speak of industry, while the affluent West End architecture and sprawling parks make for a lovely sunny day. All across its urban landscape Scotland's unofficial capital of the west teems with contradictions. At first thought, Glasgow's reputation and its cinema call to mind similar attributes. It is an industrial city of engineers known for its knife crime and penchant for fried foods. Its cinema is home to hard men, gritty social realism and an undercurrent of black humour. But the 'second city of the Empire' – so called because it was once Britain's second-largest port – is also a city of grand architecture and rich cultural heritage.

Both trends continue to shape Glasgow and its cinema, but as the city grows and will shortly become home of the Commonwealth Games, stereotypes begin to crumble. Glasgow is breaking out of the cultural moulds of *Just Another Saturday*'s workers' strikes and *A Sense of Freedom*'s gang fights and (though these topics are often revisited), the city has come into its own, beginning a trend of gentle comedies with dark undertones, kitchen sink slices of life with varying levels of grit, and even Hollywood-style escapism.

Glasgow has transformed from industrial seaport to mini-metropolis, yet it is still a Dear Green Place. Following the meandering Clyde, its banks are propped up by cranes and home to stunning vistas and modern architecture. Home to the tallest cinema in the world as well as Charles Rennie Mackintosh and Alexander 'The Greek' Thompson's grandest designs, Glasgow's identity is as unique as it is versatile – it can embolden first-time film-makers or disguise itself as San Francisco at will. If you've ever pointed at a corner of Glasgow on film in recognition or wonder, this book is for you.

The *World Film Locations* series seeks to circumnavigate the globe, finding the real-world counterpoints to the most eye-catching cinematic backdrops. This series does not seek to be encyclopaedic, but aims to tease out the interesting spaces captured on film and place them in a new context, exploring how the location relates to the film at hand and how it looks stripped bare in its natural habitat. Neither is this book a travel guide, though it would service as one. Our goal is to find the identity of the city through an examination of some of – rather than the sum of – its parts. We hope you'll find your own way to enjoy and enhance your experience of these films in your reading. ✚

Nicola Balkind, Editor

GLASGOW

City of the Imagination

Text by
PAUL
GALLAGHER

THINK OF GLASGOW ON FILM and chances are you think of crime, gangsters, poverty and hardship. Looking over the list of films covered in this book, it is clear where that thought would come from: a large proportion of them deal with at least one of those themes. But to go deeper is to find that beneath that narrow thematic surface lies a breadth of different interpretations of Scotland's largest city through cinema history. The title 'city of the imagination' is apt here, for despite – or perhaps because of – the hard and often bleak stories played out in Glasgow on the cinema screen, film-makers have continually allowed their minds to wander free from the limitations of tangible reality when looking at the city.

The camera uncovers beauty in places where it is least expected, and this is a key way that Glasgow has captured the imaginations of film-makers. Both *Ratcatcher* (Lynne Ramsay, 1999) and *Neds* (Peter Mullan, 2011) are set in the broken-down housing schemes of 1970s Glasgow, but in both cases the bleakness of the characters' situations is contrasted by the artful work of the films' cinematographers, Alwin Kuchler and Roman Osin, respectively, who find images of

beauty in lines of rubbish bags, graffitied swing-parks and seemingly bland architecture. In the apocalyptic romance *Perfect Sense* (2011), David Mackenzie presents an equally bleak imagining of a possible future, but the beauty in this scenario comes from the poignancy of Michael (Ewan McGregor) and Susan's (Eva Green) doomed love. It's a poignancy that is given weight by what could be termed the soul of the city in which it plays out: the cobbled streets of Glasgow's Merchant City and the West End's century-old sandstone tenements remain firm, speaking of the city's own ability to withstand the pressures that will ultimately wear down these human protagonists.

The same tenements are also a visual marker in *On A Clear Day* (Gaby Dellal, 2005) on the steep streets of Partick, overlooking the River Clyde and the dockyards where the film's story begins. But the effect is opposite and hopeful as the camera's raised perspective foreshadows the hope that will ultimately be restored to the main character, Frank (Peter Mullan), by the story's triumphant end. While such unmitigated success is exceptional for a character in a Glasgow-set film, the lightness and humour of the character's outlook is not; just as film-makers have uncovered beauty in the unlikeliest of Glasgow locations, so they have often revealed the city's humour in places where it wouldn't – and some might say shouldn't – be expected. This is less about the city as a location, more as a state of mind, and a Glasgow state of mind appears to be one that is laughing most of the time. It's found in *Comfort and Joy* (Bill Forsyth, 1984), a sweet and funny film that tells a very sad story, and also in *Wilbur Wants to Kill Himself* (Lone Scherfig, 2002), a film of humour and life in spite of its title. But it is another Peter Mullan film, *Orphans* (1998), that pins down something much darker and more quintessentially Glaswegian: that brand of gallows humour that asserts that no subject is beyond joking about. Indeed, the story of four adult siblings grieving

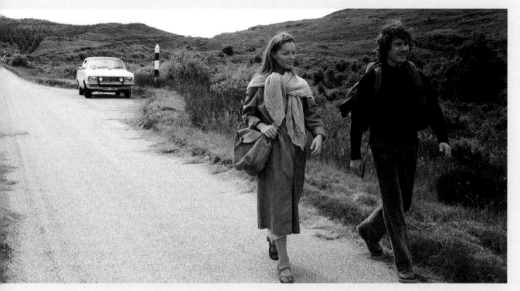

Above © 1980 Selta Films, Gaumont, SFP
Opposite © 1999 Pathé Pictures International, BBC Films

their mother, with its mix of violence, religion, magical realism and hilarity, is one that could arguably only have been brewed in Glasgow.

Mullan is clearly a key figure, both in front and behind the camera, in terms of Glasgow on film. Of equal significance, but bringing a very different focus, is Ken Loach, the film-maker who directed Mullan to global recognition as recovering alcoholic Joe Kavanagh in *My Name is Joe* (1998). Loach has made three Glasgow-set films with writer Paul Laverty, four if you include Greenock drama *Sweet Sixteen* (2002), and the pair returned to the city to film a new feature, *The Angels' Share*, in 2011. Loach always centres his stories on marginalized people and issues of social justice, and he and Laverty have done great work in holding a mirror up to the reality of broken lives in Glasgow; not just in the city of the imagination.

While Glasgow has often been and continues to be used as a stand-in for other major world cities on film, it is in the moments when film-makers have captured the city unadorned, as itself, that the most

enduring images have been created. In *Red Road* (Andrea Arnold, 2006), as the camera seems almost awestruck taking in the sight of the looming tower blocks of the title street, or in the deeply evocative opening shot of *Death Watch* (Bertrand Tavernier, 1980), beginning in the Necropolis and craning up to take in the whole sprawling city; in these moments Glasgow seems made for the cinema screen.

Moments like these are paradoxical, as they simultaneously make the city into a new, imaginary character on film and capture a specific historic moment in terms of the real city's life beyond the screen. The Glasgow that Robert Carlyle's George drives his bus around in *Carla's Song* (Ken Loach, 1996) is, in the film's fiction, the Glasgow of 1987, but at the same time, beyond the minor period adjustments, it is Glasgow as it looked when the film was shot in 1996. Bill Forsyth, Scottish director of cinema classics *Gregory's Girl* (1981) and *Local Hero* (1983), summed up this paradox in typically pointed style with the onscreen note that introduced his first, Glasgow-shot film *That Sinking Feeling* (1980): 'The action of this film takes place in a fictitious town called Glasgow. Any resemblance to any real town called Glasgow is purely coincidental.' It is in that contradiction, in the space between real physical locations and the camera's trick-telling stories, that the city of the imagination comes alive. ✤

While Glasgow has often been and continues to be used as a stand-in for other major world cities on film, it is in the moments when film-makers have captured the city unadorned, as itself, that the most enduring images have been created.

CINEMA CITY

Glasgow's Passion for Cinema

Text by
NEIL
JOHNSON-
SYMINGTON

ONE OF THE MOST SURPRISING cameos in David Hayman's film *Silent Scream* (1990) belongs to an art deco cinema, a gem of Glasgow architecture which appears transplanted in London. The 'Vogue' is revealed in all its illuminated glory once a bus destined for Soho drives past into the night. Underneath the soaring neon sign and vast canopy, a commissionaire holds open the tall doors for filmgoers coming and going. His resplendent coat, cap and white gloves personify the glamour of the cinema experience. It is not the experience of real-life Glaswegian Larry Winters, who stands near the entrance desperately drawing on his cigarette. Exhausted and miles from home, he leans against the curving tiles beside a poster for *The Mind Benders*, a cruel reminder of his state of mind. His life is about to take a tragic turn.

Silent Scream is a visually complex film which utilizes Winters's poetry, overlapping memories and hallucinations to the extent that locations often seem unreal. Yet the only thing imaginary about the cinema is its name and suggested London location. The Riddrie, designed by architect James McKissack in 1938, actually stands in north-east Glasgow. Surviving as a bingo venue, it is one of Glasgow's

cinema crown jewels. And there were many others. An overpopulated city made the popularity of cinema inevitable, and as early as 1920, cinemas were sprouting up with such speed that Glasgow Corporation attempted to halt their construction. The courts overruled them. Hardly surprising, given Glaswegians' insatiable appetite for film.

By 1935, Glasgow could boast more cinemas per capita than anywhere outside America, with total seating for 140,000 filmgoers. The names themselves promised prestige: Ascot, Coliseum, Embassy, Kingsway, Regent. In the city centre a filmgoer could easily find themselves in a palatial auditorium with 2,358 others in the Regal, or 4,367 in Green's Playhouse – once the largest cinema in Europe. Architecturally, one stood out: the 2,748-seater Paramount on Renfield Street (now a disused Odeon), whose avant-garde modern design had been hitherto unseen in Glasgow's Victorian centre. With its vast curving corner entrance and glowing facade, the Corporation praised the cinema for creating 'a new landmark between Sauchiehall Street and Argyle Street'. It also enjoyed being Paramount's busiest cinema outside America.

But impressive cinema architecture wasn't the sole preserve of the city centre. The Riddrie, like many cinemas in Glasgow's districts, was designed as a main attraction and an asset to its community. One local newspaper claimed in 1936 that crude provincial cinemas were finished: 'The modern suburban cinema must now endeavour to equal, if not surpass, its city superior in matters of comfort and luxurious surroundings if it is to succeed.' Another cinema to seize this challenge was the Lyceum in the shipbuilding district of Govan. Built in the Streamline Moderne style by renowned cinema architects McNair and Elder in 1937, the Lyceum – like the Paramount – maximized its corner site. Opening with the film *We're Going to be Rich* was a heroic statement, but the Lyceum's grandeur could not be sustained: even as a bingo venue it closed in 2006. Nonetheless, the impact

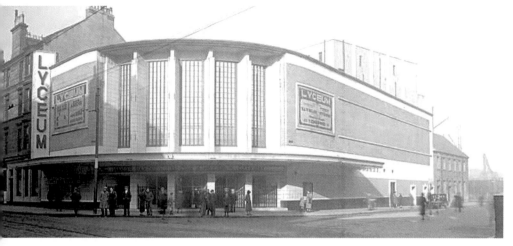

Above & opposite © Archives & Special Collections of Glasgow Libraries (Glasgow City Council)

of its entrance, comprising five tall backlit curving windows above a canopy, must have been dramatic. A hint is offered in David Blair's *The Key* (2003), in which the building sets the scene for 1970s Glasgow; however it's easily missed in this six-second vignette.

Cinemas in Glasgow provided a vital means of escape in the 1930s and 1940s. In Britain, people averaged 21 cinema visits per year in the mid-1930s; Glaswegians went at least once a week. Many visited far more. Bette Robertson – one Glaswegian out of potentially thousands – recorded in her 1937 diary that she went to the cinema four times in one week in April.

Twenty years later and cinema's allure was fading. In 1958, Glasgow's *Evening Times* reported that the 'alarming drop in filmgoing is continuing'. More cinemas may have closed had it not been for their children's matinee clubs, one of which is superbly evoked in Gillies Mackinnon's *Small Faces* (1996), set in 1960s Glasgow. Thirteen-year-old protagonist Lex Maclean finds his own escape in a cinema safe from razor gangs. Wakened by the sound of a gunshot, he's shocked but relieved to find the cinema packed with children watching a cowboy serial. As they all sing the ABC Minors song, a happy innocence surrounds him and, for a time, Lex forgets the horrors he witnessed

Despite having barely a tenth of the cinemas it once had, Glasgow still demonstrates the highest amount of filmgoing in the United Kingdom, with Glaswegians visiting up to six times a year.

through his baptism of gang-induced fire. The auditorium itself looks unremarkable, but had the shot been wider, its true significance would have been visible. This was inside William Beresford Inglis's masterpiece of cinema design: the Toledo in Muirend (1933), a Spanish-American fantasy resembling an Andalusian palace. Its facade featured hacienda windows and balconettes; the interior was of Atmospheric-style containing themed decor; and the auditorium presented mock pantiled roofs and balconies along the walls surmounted by a painted night sky ceiling. The Toledo held out longer than most – until 2001. All that remains is the facade, the magic inside having been replaced by flats.

Glasgow today is a very different place from the one of the 1930s. That golden era of filmgoing would appear to be a historic phenomenon. Or maybe not. Despite having barely a tenth of the cinemas it once had, Glasgow still demonstrates the highest amount of filmgoing in the United Kingdom, with Glaswegians visiting up to six times a year, compared to the national average of just below three. Its cinemas are trailblazers too: the shimmering IMAX (1999) – Britain's first titanium-clad building; the towering Cineworld (2001) – officially the world's tallest cinema; and the Glasgow Film Theatre – formerly the Cosmo (1939), another of McKissack's modernist cinemas – which receives nearly double the number of screen admissions than the nationwide average. Considering that the Glasgow population has been exposed to a cityscape once incredibly peppered with at least 130 different cinemas, perhaps this unquenchable enthusiasm for film is to be expected. ✤

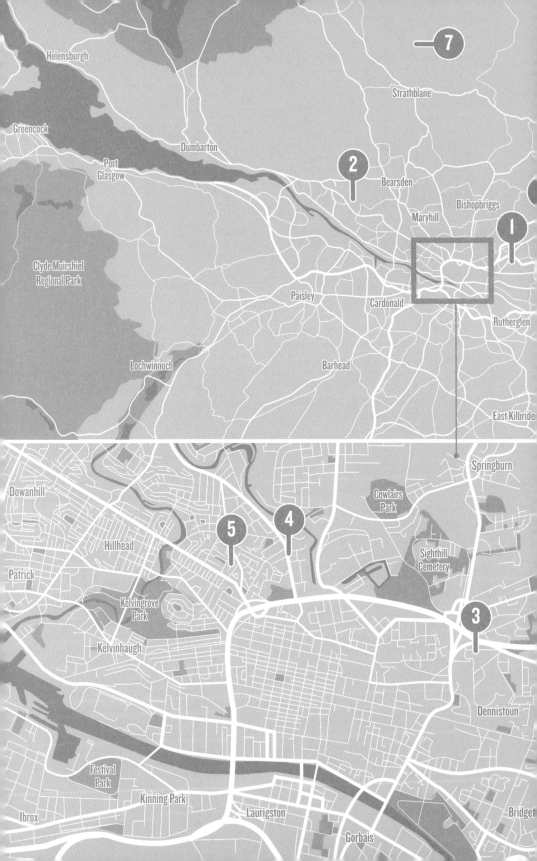

GLASGOW LOCATIONS

SCENES 1-7

maps are only to be taken as approximates

O LUCKY MAN! (1973)

LOCATION

HM Prison Barlinnie, 81 Lee Avenue, Riddrie, G33 2QX

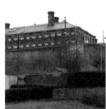

HAVING BEEN FOUND GUILTY of a trumped-up fraud charge and imprisoned for five years, journeyman coffee seller Mick Travis (Malcolm McDowell) finally wins his release, having convinced the prison governor (Peter Jeffery) that – thanks to a conversion to Humanism – he has become a model prisoner. The prison sequence in Anderson's film is comprised of several exterior establishing shots (library footage of Wormwood Scrubs); cell and office interior shots filmed on studio sets at Colet Court (the production base of Thames Television's Euston Films subsidiary in the early 1970s); and, finally, on location outside the entrance to HM Prison Barlinnie. Security regulations in English prisons at the time made it impossible to film anyone actually coming through a prison doorway and so, for the only time in the production, filming moved north of the border. Anderson, a Scot, was delighted. In his personal diary he described the location and filming experience thus: 'a large plain gate (only a pity the prison buildings could not be seen behind) and a splendid large wall and a good space of roadway, remote from through traffic, in front. Scottish prison officials of great pleasantness and tolerance of our absurdity.' Rather appropriately given the compressed, metamorphic journey that Mick Travis takes through the penal system, shortly after filming took place Barlinnie's world-renowned 'Special Unit' was opened; a facility that emphasized rehabilitative treatment of prisoners and produced former Glasgow gangster Jimmy Boyle, the prison's most well known success story.
➻ *Jez Conolly*

Photos © Lewis Smith

Directed by Lindsay Anderson

Scene description: *Mick the model prisoner is released*
Timecode for scene: *2:13:58 – 2:20:28*

Images © 1973 Sam, Memorial Enterprises

JUST ANOTHER SATURDAY (1975)

LOCATION *Abbotshall Avenue, G15 8PL and Achamore Road, G15 8QS*

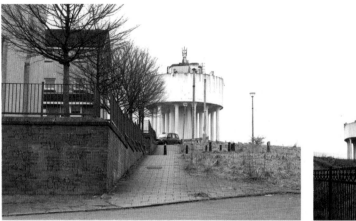

IN 1970S GLASGOW, beneath the glossy nightlife, beyond the dramatic architecture of an era long gone, there was a grittier world of greying concrete and anonymous tower blocks. Deeper still, there coursed an undercurrent of strain and conflict. Director John Mackenzie immediately draws the audience into this stark and unyielding environment in *Just Another Saturday*, part of the BBC's Play For Today anthology and a narrative that focuses on a young protestor named Jon (played by Jon McNeil) and his experiences at The Orange Parade. Establishing shots of Abbotshall Avenue and its interchangeable high-rises connote desolation and gloom before the day has even begun. When John sets off from his flat to the protest the camera immediately settles on an unspoken darkness; the first shot being a view towards Clydebank. Just four years earlier, the Upper Clyde Shipbuilding Consortium had been refused a £6 million loan by the Conservative government under Edward Heath, leaving the shipping industry in a state of decline and many workers unemployed. Understandably there was still bitterness about this at the time and Mackenzie's direction could easily be interpreted as a pointed comment on the sad history of the area. This is underlined further by his follow-up shots of flaking verandas, wandering children and dismal architecture. These elements, combined with some carefully placed point of view and tracking shots, gradually build an impression of disadvantage, injustice and inequality: three key motifs that weave their way through Mackenzie's understated but unafraid portrayal of retro Glasgow. ➻*Helen Cox*

Photos © Lewis Smith

Directed by John Mackenzie
Scene description: Jon leaves home to prepare for a march
Timecode for scene: 0:09:30 – 0:11:28

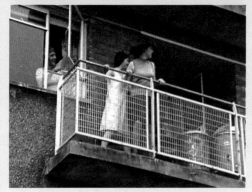
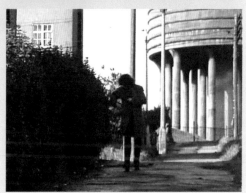

Images © 1975 BBC

DEATH WATCH/LA MORT EN DIRECT (1980)

Glasgow Royal Infirmary, G31 2

FROM ITS EARLIEST SCENES – such as the Leone-esque crane shot rising high over the Necropolis to composer Antoine Duhamel's jabbing strings, and this one, as Roddy leaves the Royal Infirmary – it is clear that *Death Watch* is no ordinary filmic depiction of Glasgow. Deserving of mention alongside more celebrated 'outsider' visions of the United Kingdom (Antonioni's *Blow-Up*, Polanski's *Repulsion*) it is an adaptation of the 1974 science fiction novel by D. G. Compton, *The Continuous Katherine Mortenhoe*. French director Bertrand Tavernier crafts a dystopian drama about TV director Roddy (Harvey Keitel) who has a camera implanted in his eye to record everything he sees. He is given the task of filming the final days of the terminally-ill Katherine (Romy Schneider) for the reality show of the title. Tavernier went against professional advice to make the film in Glasgow, arguing that there was no need for the 'false futurism' of studio sets, that the city's Victorian buildings would still be standing proud in decades to come. Both the director and his cinematographer Pierre William Glenn embrace the contrast between this nineteenth-century architecture and the city's more modern structures. Made years before the explosion of reality television, Tavernier's film is striking above all in its prescience. Its foregrounding of the act of voyeurism invites comparisons with Michael Powell's *Peeping Tom* (1960). Like that film, the director asks uncomfortable questions of his audience but also of his own role in the capturing and manipulating of reality. **Pasquale Iannone**

Photos © Lewis Smith

Directed by Bertrand Tavernier
Scene description: Roddy leaves the Royal Infirmary
Timecode for scene: 0:03:58 – 0:05:07

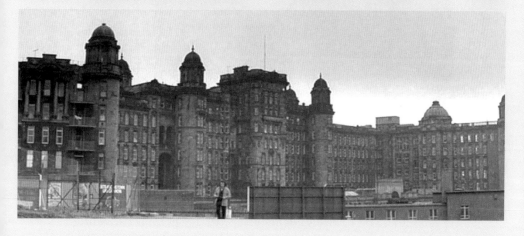

Images © 1980 Selta Films, Gaumont, SFP, Little Bear, Sara Films

THAT SINKING FEELING (1980)

LOCATION *A patch of waste-ground off Maryhill Road in the shadow of the Cedar Court flats, G20*

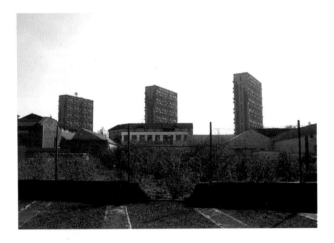

BILL FORSYTH'S LYRICAL DEBUT captures his hometown in all its festering decay at the dawn of Thatcher's Britain, with the future European City of Culture wearing its years of neglect on its dilapidated tenements and patchwork pavements. The film centres on a posse of unemployed teenagers who, frustrated by life on the dole, embark upon an audacious robbery of a local warehouse containing stainless steel sinks that will fetch £60 a pop on the black market. 'An hour in there and we could shift eighty, maybe ninety of them into a van,' estimates Ronnie (Robert Buchanan), the heist's mastermind. '60 × 90!' exclaims one of his partners in crime, 'that's over a hundred quid.' Planning this larceny shakes these young men from their jobless funk but Forsyth still paints a rather bleak future for his characters (charmingly performed by Glasgow Youth Theatre greenhorns). Early in the film, Ronnie, while in the back seat of a car, confesses to two friends that he tried to kill himself earlier in the day. Forsyth, in what would become his trademark, wraps this barbed statement within a cushion of whimsy. Ronnie's unsuccessful suicide method was drowning himself... in a bowl of cornflakes and milk. Forsyth cuts from this blackly comic interior scene in medium close-up to a wide exterior shot that pans from Govan's three iconic tower blocks in the distance to a navy-coloured rust bucket marooned on a sodden waste-ground. The boys' car is on bricks, its wheels long removed. The message is blunt: these kids are going nowhere. **→ Jamie Dunn**

Photo © Lewis Smith

Directed by Bill Forsyth

Scene description: Ronnie, Vic and Wal discuss suicide in an abandoned car
Timecode for scene: 0:05:48 – 00:08:20

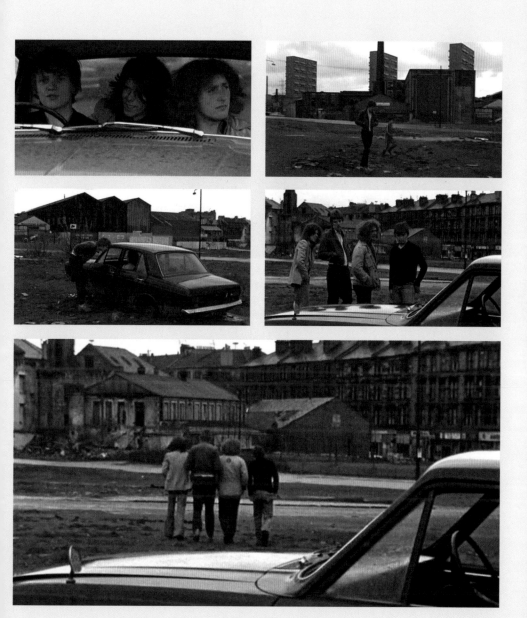

Images © 1980 Minor Miracle Film Cooperative, Lake Films, Glasgow Youth Theatre

A SENSE OF FREEDOM (1981)

Napiershall Street, North Kelvinside, G20

A SENSE OF FREEDOM was the final collaboration between director John
Mackenzie and writer Peter McDougal. Together their work has proven
influential in shaping the image of Glasgow as a brutal and violent city
that sags in the wake of industrial decline. The film is loosely based on the
autobiography of the notorious Glasgow gangster-turned reformed artist
Jimmy Boyle, played here by David Hayman. Born in the Gorbals in 1944,
Boyle quickly earned a reputation as Scotland's most dangerous criminal,
and at the age of 24 he was sentenced to life imprisonment. The first part of
the film focuses on Boyle's life in the Gorbals and depicts an environment
governed by fear and brutality. This is brought to the fore during a scene in
which Boyle and his supporters engage in a violent street fight with a rival
gang. The public setting of this scene, which was filmed on and around
Napiershall Street, conveys a culture in which extreme acts of violence are
commonplace. This becomes yet more apparent when the fight continues
onto a passing bus amid frightened screams from its passengers. Mackenzie's
invasive use of hand-held camera enhances this sense of sheer disorder
and brutality. Proposals for *A Sense of Freedom* were met with controversy
and resistance and Glasgow District Council denied the film-makers
permission to shoot in certain locations, including council housing and a
pub. Furthermore, the Scottish Office prohibited filming in Scottish prisons,
and the prison scenes instead had to be shot in Kilmainham Jail in Dublin.
Linda Hutcheson

Photo © Lewis Smith

Directed by John Mackenzie
Scene description: *A street brawl*
Timecode for scene: *0:10:55 – 0:13:26*

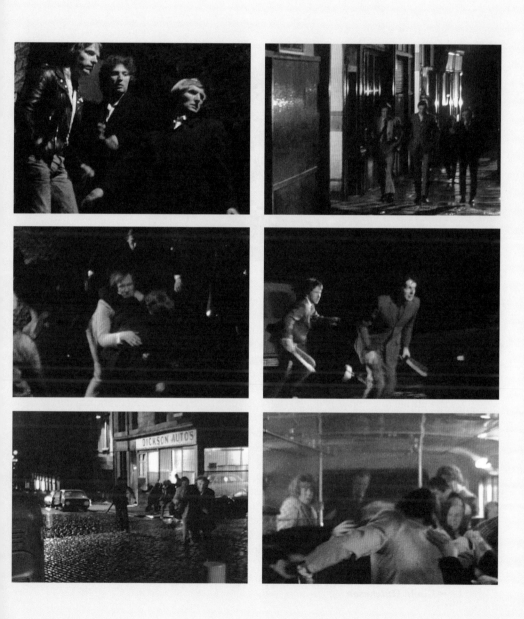

Images © 1981 STV

GREGORY'S GIRL (1981)

Cumbernauld Centre, Central Way, Cumbernauld, G67 1NE

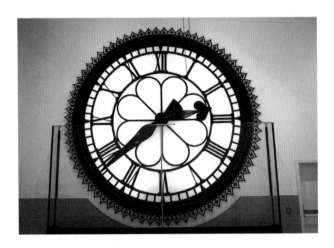

AWKWARD TEEN GREGORY (John Gordon Sinclair) has plucked up the
courage to ask the girl of his dreams, Dorothy (Dee Hepburn), on a date, and
arranges to meet her 'at the clock in the plaza'. As he waits anxiously for
Dorothy to arrive, and time ticks by inexorably on the giant clock face behind
him, he has no clue about the layers of planning that have brought him there,
or of the events that will soon unfold in ways he would never have imagined.
With only his second feature, Bill Forsyth (who went on to even greater
acclaim with *Local Hero* [1983]) crafted a sweet and charming comedy about
the power and mystery of girls to boys of teen (or any) age. His reputation was
subsequently and unfortunately tainted by a disastrous spell in Hollywood and
an inferior sequel to *Gregory's Girl* in 1999, which sadly still stands as his last
film to date. Cumbernauld was one of a handful of 'New Towns' built in the
1950s, as the slum tenements of Glasgow were demolished and the resultant
overspill sent tens of thousands into the suburbs and New Towns beyond.
The clock itself was a gift from Glasgow on the occasion of Cumbernauld's
twenty-first birthday in 1977, once standing in the city's St Enoch's Station.
It has since been moved from its original position in the stairwell of the old
Cumbernauld Centre as seen in the film, and can now be found in the new
Antonine Centre just across the road. **⥗Paul Greenwood**

Photo © Lewis Smith

Directed by Bill Forsyth
Scene description: Gregory waits nervously for his date with Dorothy
Timecode for scene: 1:04:32 – 1:06:40

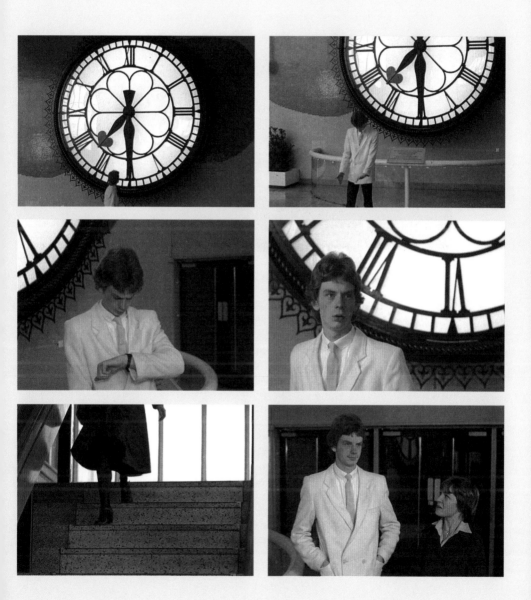

Images © 1981 Lake Films, STV

MONTY PYTHON'S THE MEANING OF LIFE (1983)

LOCATION *The Campsie Fells, near Milngavie, G63*

THE FINAL MONTY PYTHON FILM returns to the plot-less structure of the first. But, while *And Now for Something Completely Different* (Ian McNaughton, 1971) is a low-budget collection of sketches first broadcast on television, *The Meaning of Life* is a colossal, madcap revue show that seeks nothing less than to determine the purpose of existence – and that could only be contained by the cinema screen. Its surreal sequences take place around the world and across history, but were all filmed in Britain, the most ingenious use of location shooting coming as Scotland's Campsie Fells double for South Africa in a scene recalling, and perhaps parodying, Cy Endfield's *Zulu* (1964). The location is part of the joke: our setting is announced as the '1st Zulu War, 1879 (Glasgow)'. Although the soldiers they command are being slaughtered by the native hordes, British officers, led by John Cleese, have more important business to which to attend. One of them, played by Eric Idle, has woken to find his leg was bitten off by a tiger while he slept – and so, naturally, the officers abandon the battle and stride off in search of it. The Campsie Fells compose one of Scotland's great natural beauty spots, and form an oasis of serenity it is hard to believe lies so close to Glasgow. The hills are renowned among tourists and hikers as a walking location, but for fans of Monty Python they will always be known as a filming location – and the site of the First Zulu War. **⇢Scott Jordan Harris**

Photo © Lewis Smith

Directed by Terry Jones
Scene description: *A Tiger in Africa*
Timecode for scene: 0:49:48 – 0:55:26

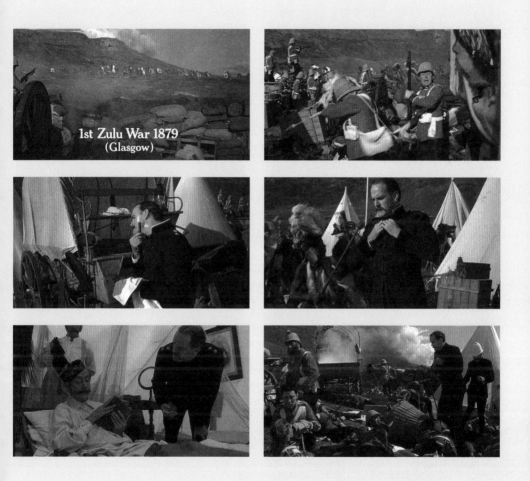

1st Zulu War 1879
(Glasgow)

Images © 1983 Celandine Films, The Monty Python Partnership, Universal Pictures

GLASWEGIAN COMEDY

A Distinct Sense of Humour

Text by
KEIR
HIND

THE GLASWEGIAN STYLE OF HUMOUR is, like Glasgow itself, a relatively recent development. Glasgow grew from a city with under 100,000 people to become the largest city in Scotland over the nineteenth century, mainly because the River Clyde grew steadily in importance as a port and a manufacturing base during the Industrial Revolution. People arrived from two main sources: Ireland, and the Highlands and Western Isles of Scotland. The comedic sensibilities that were brought can be – broadly – typed as a genial and occasionally boisterous Irish humour, seen in overdone form in many John Ford films, and a gentle and sometimes whimsical Highland and Islands humour, seen in Neil Munro's Para Handy stories. These styles, given an edge by the poor living conditions in the city, would eventually blend together to form a distinctive Glaswegian humour which can be by turns wry and cutting or lively and affable.

Apart from early sequences in *The Maggie* (Mackendrick, 1954), which was based on the Para Handy stories without acknowledging them, no comedy film would be set in Glasgow for some time, but whilst cinema overlooked them, Glaswegians established a sure sense of humour and identity. A well-defined Glaswegian humour had emerged in the city, reflected and advanced by theatre and music hall acts. In the 1970s, Billy Connolly, who evolved, miraculously, from a welder into a folk musician into a comedian, made his own exuberant version of Glaswegian humour popular across Britain and later worldwide. But Connolly's Glaswegian acting roles came in films like *Just Another Saturday* (John Mackenzie, 1975), as tough, glowering characters, at odds with his public persona. There simply weren't enough good comedic roles for Scots as a whole and 'tough' Glaswegians in particular.

It wouldn't be until 1980 that an indigenous Glaswegian comedy was released. Bill Forsyth's *That Sinking Feeling* (1980) begins with an intertitle stating, 'The action of this film takes place in a fictitious town called Glasgow. Any resemblance to the real town called Glasgow is purely coincidental.' Fair warning, because all of the main parts in the film are played by teenage members of the Glasgow Youth Theatre. But by depicting poverty the film very accurately reflects its setting. In making a caper movie, in which a group of boys plan a heist of (locally produced) sinks, Forsyth managed to find a form that was fun but didn't shy away from social conditions – these boys steal because they're poor. Tellingly, when the gang leader outlines

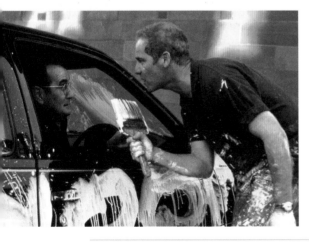

Above © 1980 Glasgow Youth Theatre, Lake Films
Opposite © 1998 Alta Film, Arte, Channel Four Film

what they'll be stealing, he asks, 'What's this area famous for?' and receives the reply 'Multiple social deprivation!' instead of 'sinks'.

This film's modest success allowed Forsyth to make a second film, *Gregory's Girl* (1981), about a teenager in love (or so he thinks) with a girl on the school football team. This film, praised for its quirky take on school romance, finds humour in the emotional incompetence of schoolboys, contrasted with the schoolgirls' competence. Whilst *Gregory's Girl* doesn't overtly address poverty as *That Sinking Feeling* did, it is set in the 'New Town' of Cumbernauld, set up just outside Glasgow to provide housing for residents of poorer areas of the city without, it is generally agreed, being a huge improvement. In a sense *Gregory's Girl* grows a rose in a dustbin and its location shooting keeps viewers aware of the setting.

The film was a critical success and, perhaps most importantly, was highly profitable. Forsyth made *Local Hero* (1983) outside Glasgow, but returned to make *Comfort and Joy* (1984). This examines the dichotomy between humour and social conditions in his work by having Bill Paterson's Disc Jockey investigate a gang war between ice-cream van owners. By examining this culture clash, Forsyth shows again that comedy can benefit by recognizing social realities.

Forsyth's success in portraying Glaswegian humour cinematically also had a kick-starter effect as the people associated with his films went on to make more Glaswegian comedies. His former production partner Charles Gormley made *Heavenly Pursuits* (1985), a light comedy about apparently miraculous events; making use of Glasgow's City Chambers amongst other settings. Gregory himself, John Gordon Sinclair, appeared in *The Girl in the Picture* (Parker, 1986), another light comedy, set in Glasgow's affluent West End. Peter Capaldi, who appeared in *Local Hero*, became a successful director, winning an Oscar for best short film, and came to Glasgow to direct the poorly received *Strictly Sinatra* (2001). However, he later achieved massive success playing the hilariously profane Scottish spin doctor Malcolm Tucker on television in *The Thick of It*, and later on film in *In The Loop* (2009), a political satire set in London and America but directed by another Glaswegian, Armando Ianucci.

Glaswegian film has become more rounded as a whole with the growth of comedy films. The city's 'hard man' image was difficult to pass over, but now even films that examine harsh social realities tend to show that humour is still present. Ken Loach's collaborations with the Glaswegian screenwriter Paul Laverty have been particularly good at this. One example is *My Name Is Joe* (1998), starring Peter Mullan as a recovering alcoholic, which explores the ridiculous when Joe's football team can't play because both teams have shown up in West Germany strips. It's a small moment in what is eventually a tragic film, but it does enrich the realist drama with comedy. Notably, the Loach-Laverty team continued this approach in their subsequent films set in the west of Scotland, *Sweet Sixteen* (2002) and *Ae Fond Kiss...* (2004), while Peter Mullan chose a dark comedy, *Orphans* (1998), as his directorial debut. The fact that Mullan was able to do so indicated that Glasgow had become a viable place to set comedies in a way that it simply was not twenty years before. And more evidence can be seen in highlights of the film when Gary Lewis's character, insisting on carrying his mother's coffin alone (with predictable results), uses the line, 'She ain't heavy – she's my Mother.' If a Glaswegian film can get away with that kind of joke, then Glasgow humour is here to stay. ✦

Glaswegian film has become more rounded as a whole with the growth of comedy films. The city's 'hard man' image was difficult to pass over, but now even films that examine harsh social realities tend to show that humour is still present.

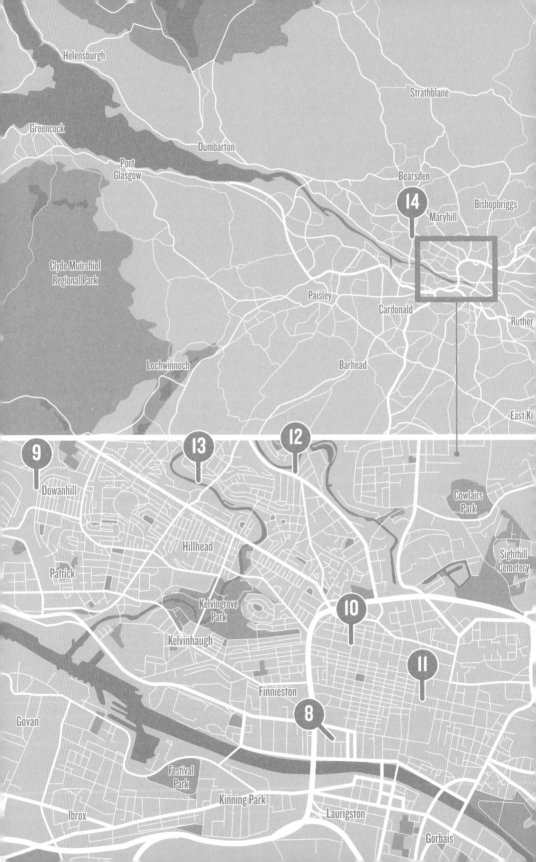

GLASGOW LOCATIONS

SCENES 8-14

maps are only to be taken as approximates

COMFORT AND JOY (1984)

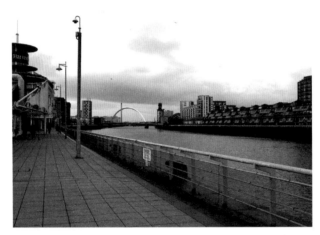

LOCATION *South Clydeside, beside the Kingston Bridge across the River Clyde, G5*

BILL FORSYTH'S FILM is a subtle comedy played out against the Glasgow Ice Cream Wars of the 1980s. It is also a character study of Alan 'Dickie' Bird (Bill Paterson), a local radio presenter deserted by his kleptomaniac girlfriend, Maddy (Eleanor David) in the run-up to Christmas. Here Dickie is pictured walking along the banks of the River Clyde and talking into his mobile tape recorder. Behind him is the twin-span ten-lane Kingston Bridge, the largest road bridge of its kind in the country and a signifier of the urban disaffection that characterizes his personal crisis and feelings of loss. The recording starts out as an attempt at serious radio journalism; he recently witnessed an attack on an ice cream van by a rival firm which has led him to question what goes on beneath the surface of the city in which he lives. But will anyone listen? Chris Menges's moody Whistler-esque cinematography captures the scene in the cold blues and greys of the Glaswegian winter. Dickie looks out to the distance and to the life ahead of him as the fog turns the dockside 'furniture' into indistinct shapes; all he sees is a bleak and uncertain future. The city seen here is an alienating, lonely place to be at Christmas. This riverside scene contrasts sharply with the chaotically crowded opening of the film set in a busy shopping mall full of Christmas shoppers. It ends with Dickie, still talking into his microphone, asking his girlfriend to come back.
↝Caroline Whelan

Photos © Lewis Smith

Directed by Bill Forsyth
Scene description: Dickie ponders his future while walking along the Clyde
Timecode for scene: 0:37:09 – 0:38:55

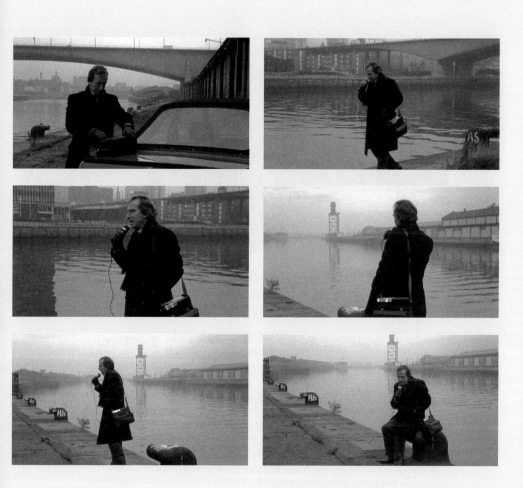

Images © 1984 Kings Road Entertainment, Lake (Comfort and Joy) Limited

THE GIRL IN THE PICTURE (1986)

LOCATION

John Hendry Photography, 94 Turnberry Road, Hyndland, G11 5AR

CARY PARKER'S *The Girl in the Picture* is a fondly remembered but hard-to-find film set primarily in Glasgow's West End. John Gordon Sinclair stars as Alan, a twenty-something aspiring photographer. Working under Smiley (Paul Young) as a wedding photographer at Smile Please Studios, he is working hard on an artistic portfolio but is troubled by his lackluster relationship with student Annie (Caroline Guthrie). In an early scene, Alan revs up his old blue car as Annie takes to the paths on her bicycle. Arriving in tandem at the photography shop, Annie rounds the corner, waving hello to Bill and his proud new houseplant just as Alan pulls up at the front door. The photography studio acts as a revolving door, drawing together the various narrative strands as Alan's relationship deteriorates while he works on the engagement and marriage photographs of Bill (a young Gregor Fisher) and Annie (Caroline Guthrie). Smile Please Studios still stands in the Hyndland area, now under the rather less kitschy moniker of John Hendry Photography. The location is apt given that snapshots tell the true story behind this lugubrious Glasgow tale, providing much needed pathos and underlining the importance of taking stock in life's many wacky and wonderful relationships.
•>Nicola Balkind

Photo © Alasdair Watson

Directed by Cary Parker
Scene description: Alan arrives at work as Annie passes on her bike
Timecode for scene: 0:08:52 – 0:11:32

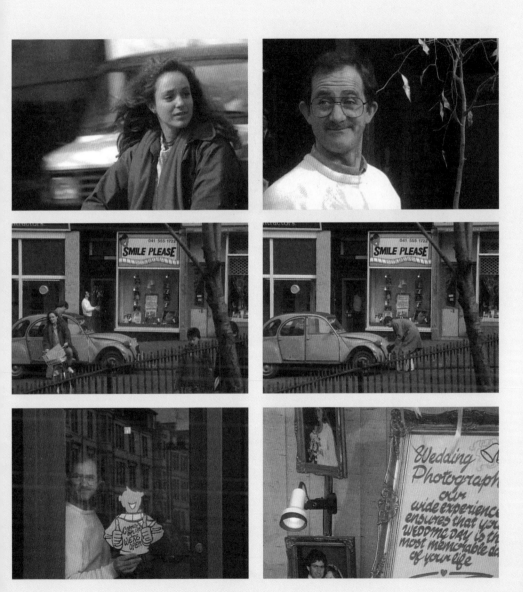

Images © 1986 Antonine Films

THE BIG MAN AKA CROSSING THE LINE (1990)

LOCATION *Scott Street, looking towards Sauchiehall Street, G1*

IN THE BIG MAN, Liam Neeson plays Danny, a broke, unemployed miner struggling to support his young family and haunted by his past. Brimming with untapped bitterness and anger, he served jail-time for assaulting a police officer during the turbulent miner's strikes (though he considered it a political crime). His pugnacity is spotted by a Glasgow mob boss who enlists him in a high-stakes bare-knuckle boxing fight; with few other opportunities available to him, he can hardly refuse. Danny relocates to Glasgow where he is trained and mentored by childhood friend Frankie (Billy Connolly). Pacing around the streets of the city, Frankie's effusive monologue in this scene neatly conveys their modest roots ('everything's bloody huge, even the breakfasts!'). The elevation of Scott Street grants the pair an imposing, arresting view of Pitt Street below, stretching for half a mile to the south; a backdrop which fills the frame and dwarfs the shell suit-clad men. They are small fish in a bigger, ultimately more perilous pond. Danny and Frankie come from a close-knit mining village struggling to find its identity following the devastation of pit closures. He subsequently becomes a symbol of hope for the community to cling to, and they rally round him, right down to the Spartacus-esque climactic showdown. As the title suggests, this is a film dealing with deep-seated working-class pride. 'You always have to be the big man!' chides his wife; but perhaps there is a greater pride at stake here. ⚫ *John Nugent*

Photo © Lewis Smith

Directed by David Leland

Scene description: Frankie marvels at the size of Glasgow

Timecode for scene: 0:39:08 – 0:40:35

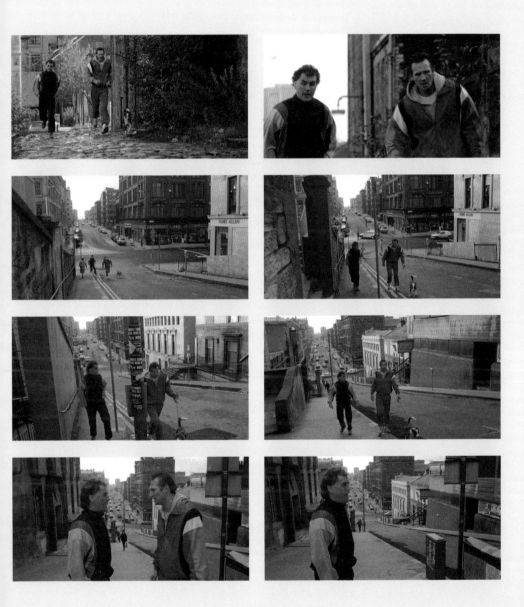

Images © 1990 Miramax

CARLA'S SONG (1996)

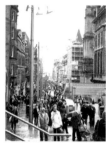

BUSKING, IN KEN LOACH'S exposition on altruism, is what draws 'regular Joe' George (Robert Carlyle) into an extraordinary journey where he is confronted by the much greater picture of social injustice. Carla's nightmares from her time fighting for the Sandinistas prompt George to buy them tickets to return to her native Nicaragua. There, George witnesses first-hand how civil war against the CIA-sponsored Contras ravages close-knit communities and separates loved ones. This is a world away from the commercial environment of Buchanan Street. When Carla performs her Masaya dance, the most striking contrast is not between the white folds of her skirt and the early evening darkness, but rather how tradition and passion overshadow the harsh light of retail displays and First World concerns. However the generosity of the bystanders in this scene depicts Glasgow not as a callous, anonymous city but as a place where a sense of community still exists. George has a remarkable ability to spot an individual – not to mention pretty – face in a crowd, even while driving his bus. Cynicism aside, George is the character who proves routines can be interrupted, figures of authority can be thwarted, and that the individual can still influence events. Glasgow is the setting for only the first third of the film but its influence continues throughout. In Nicaragua, George swaps his smiley-emblazoned (it is 1987) 'Welcome to Glasgow' T-shirt with a local barfly in one of the film's most amusing scenes, but in the process sets up one of its most harrowing. **Susan Robinson**

Photos © Guy Phenix

Directed by Ken Loach

Scene description: A bus driver watches a Nicaraguan refugee dance on Glasgow's busy streets
Timecode for scene: 0:12:35 – 0:14:54

Images © 1996 Alta Films, Channel Four Films

TRAINSPOTTING (1996)

Café D'Jaconelli, 570 Maryhill Road, G20 7EE

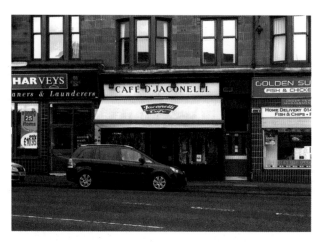

ALTHOUGH SET PRIMARILY in Edinburgh, *Trainspotting* was shot primarily in Glasgow and, while not instantly recognizable in the film, Maryhill Road's Café D'Jaconelli has become one of the Glaswegian sites most famous for featuring in what is surely the best British film of its decade. The cafe is where Ewan McGregor's Renton meets Ewen Bremner's Spud to calm him down ahead of a job interview. The scene begins as the pair share a strawberry milkshake, each sucking a straw as urgently as they can in a race to finish the drink. Then, they discuss how difficult job interviews are for those who wish to be permanently unemployed. As Spud points out, if he doesn't try hard enough he may have his benefit payments cut but, if he tries too hard, he might get the job – which would be even worse. To ease Spud's nerves, Renton suggests he indulge in something a little stronger than strawberry milkshake: a 'wee dab' of amphetamine. In life, Café D'Jaconelli is as it appears on screen: a small, quiet, pleasant cafe. Since 1996, however, it has become somewhat less quiet, as an increased number of customers seek it out simply to sit where Renton and Spud sat and, often, to order what Renton and Spud ordered. This has caused uncharitable citizens of other Scottish cities to create a standing joke that, because of its appearance in *Trainspotting*, Café D'Jaconelli is the only place in Glasgow where two men can share a milkshake without being beaten up. •◦*Scott Jordan Harris*

Photo © Lewis Smith

Directed by Danny Boyle
Scene description: 'Good luck, Spud!'
Timecode for scene: 0:12:58 – 0:13:38

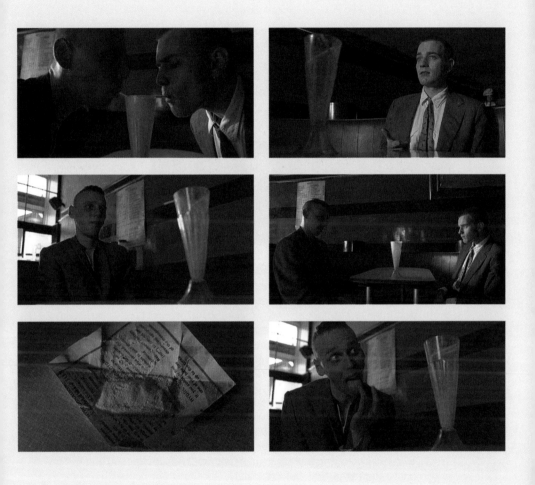

Images © 1996 Channel Four Films, Figment Films

MY NAME IS JOE (1998)

LOCATION *The River Kelvin Walkway through Kelvinside, a pedestrian bridge at the entrance to the Botanic Gardens, G12 0UE*

IN ANY MAJOR URBAN SPRAWL the line between rich and poor is paper thin. So too the divide between poverty and abject poverty; abject poverty and criminality; and between happiness and misery. Ken Loach explores these fault lines in *My Name Is Joe*, the English director's second feature set primarily in Glasgow. The film's characters are all walking invisible tightropes. Our eponymous protagonist, played with customary intensity by Peter Mullan, is a recovering alcoholic living on the dole in a threadbare flat in Maryhill. Joe keeps busy by coaching a ramshackle Sunday league football team, several members of which also struggle with addiction, including Liam (David McKay), a likable young father who is in recovery along with his child's mother Sabine (Anne-Marie Kennedy), who suffered from a period of heroin dependency. Their progress as parents is being monitored by Sarah (Louise Goodall), a community health visitor who begins a tentative romance with Joe. Loach places emphasis on how Joe, Liam and Sabine are trapped by their unfortunate circumstances and uses Glasgow's disparity of wealth to add credence to this immobility. A stone's throw from down-at-heel Maryhill is well-to-do Kelvinside. It is this affluent area of town, at an idyllic spot by the River Kelvin, that Loach and screenwriter Paul Laverty choose as backdrop for Joe's rejected marriage proposal to Sarah. The implication being that for Joe, and others in his social milieu, happiness and prosperity are very much in sight, but in reality they might as well be a million miles away.
↝Jamie Dunn

Photo © Alasdair Watson

Directed by Ken Loach
Scene description: Joe proposes to Sarah while walking along the River Kelvin
Timecode for scene: 0:38:16 – 0:41:57

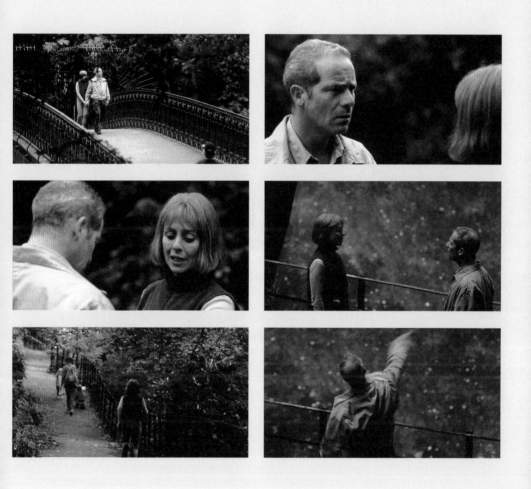

Images © 1998 Alta Film, Arte, Channel Four Film

ORPHANS (1998)

All Saints Scottish Episcopal Church, 10 Woodend Drive, Jordanhill, G13 1QS

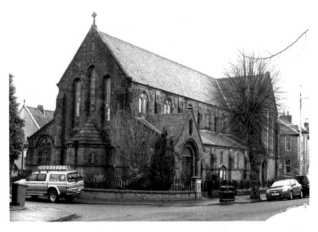

PETER MULLAN'S BLACK COMEDY, a bittersweet ode to the city where he was raised, follows four Glaswegians on the night before their mother's funeral. Through a series of increasingly bizarre misadventures, the grown-up 'orphans' endure an unforgiving city indifferent to their grief. Michael (Douglas Henshall) gets stabbed after a pub brawl, younger brother John (Stephen McCole) becomes hell-bent on revenge, and wheelchair-bound sister Sheila (Rosemarie Stevenson) is left to fend for herself. Meanwhile eldest brother Thomas (Gary Lewis) stubbornly persists in keeping his mother's dying wish that he keep vigil over her coffin in the church. Driven by fierce pride and staunch Catholicism, Thomas presents an exaggerated portrait of grief, his siblings' problems coming a distant second to his own melancholy. Nothing will shake his resolve – not even when a long-brewing storm threatens to destroy the church itself. A gust of wind loosens a chandelier, shattering a statue of the Virgin Mary. The gale lifts the roof of the church clean off. Exposed to the elements and a blizzard of Bible pages, the deranged Thomas raises his arms aloft in a crucifix pose, before curling into a foetal ball. The symbolism is inescapable: even in a place of worship, Thomas is first and foremost his ma's boy. The scene's surreal power is heightened because Mullan filmed in an actual church, albeit one of Protestant faith. Clever set dressing and sparingly used special effects transformed the All Saints Scottish Episcopal Church into an apocalyptic manifestation of Thomas' grief. Fortunately, in real life, it remains unscathed. ••*Simon Kinnear*

Photo © Guy Phenix

Directed by Peter Mullan

Scene description: *A grieving son's vigil for his dead mother is interrupted by a storm*
Timecode for scene: *1:06:25 – 1:07:17*

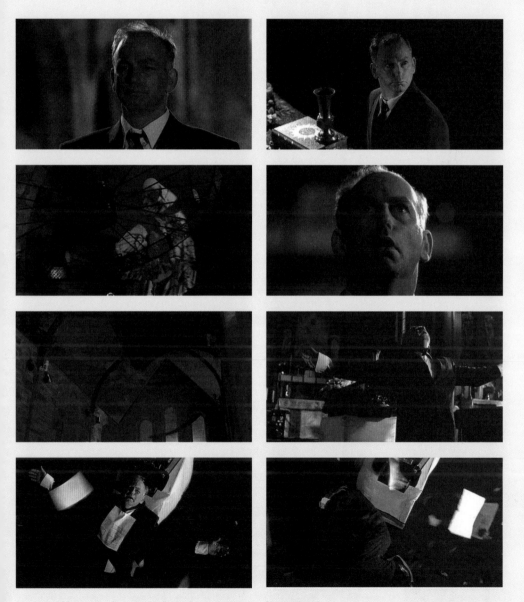

Images © 1998 Antoinine Green Bridge, British Screen Productions, Channel Four Films

THE GIFT OF CONSTRAINT

Text by PASQUALE IANNONE

Danish-Scottish Collaboration and the Advance Party

THE RUSSIAN COMPOSER IGOR Stravinsky was noted for self-imposing a whole manner of constraints on his work, arguing that 'the more constraints one imposes, the more one frees oneself from the shackles that chain the spirit'. As a dictum, it appears more than relevant to one of the most iconoclastic film movements of the past two decades, Denmark's Dogme 95. The ten rules that made up the Dogme 'Vow of Chastity' (shooting must be done on location, the camera must be hand-held, the film must be in colour, etc.) empowered a raft of film-makers in Denmark and across the world and produced important films such as *Festen* (Thomas Vinterberg, 1998), *The Idiots* (Lars Von Trier, 1998) and *Julien Donkey-Boy* (Harmony Korine, 1999).

It was at a screening of Lars Von Trier's post-Dogme film *Dancer in the Dark* (2000) that Gillian Berrie, producer and co-founder

of Glasgow-based production company Sigma Films, first discussed the idea for a Danish-Scottish collaboration with Von Trier's Zentropa Entertainments. The companies' first venture together was David MacKenzie's *The Last Great Wilderness* (2002), an unlikely, yet effective genre hybrid (crime/comedy/horror) which was followed by works such as the Glasgow-set comedy-drama *Wilbur Wants To Kill Himself* (Lone Scherfig, 2002) and *Manderlay*, Von Trier's 2005 follow-up to *Dogville* (2003). As Mette Hjort notes: 'A strong sense of affinity, combined with shared commitment to film production as a form of institution-building or milieu development, at least partly explains the broad-based and long-term nature of collaborative efforts between Sigma and Zentropa.' Building on this collaboration, Von Trier proposed the Advance Party – a three-film initiative which, according to Berrie, 'was an attempt to do for Scotland what […] Von Trier's rule-governed and now globalized Dogme movement did for Denmark and Danish film'. The initiative would produce three films by first-time feature film-makers, all shot on location in Scotland. The films would be shot digitally, over a period of six weeks each and with an individual budget of no more than £1.2 million. Constraints were also imposed on the narrative with the same set of characters to be played by the same actors across the triptych (there was, however, no stipulation in terms of how the characters should be deployed, they could be at the heart of the plot or glimpsed fleetingly). Writing in *Sight & Sound*, critic Hannah McGill rightly draws a comparison with Belgian director Lucas Belvaux, who attempted a similar feat some years before

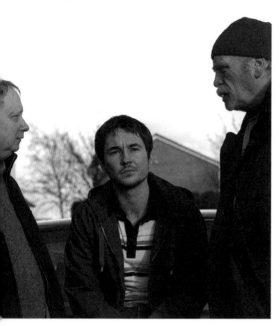

Above © 2010 Sigma Films, Zentropa Entertainments, Advance Party Films
Opposite © 2002 Zentropa Entertainments 6, Wilbur Ltd.

with his hugely underrated *Trilogie* (2002). In an interview with Stuart Henderson, Belvaux outlines his approach to his three films:

The point of departure [was] an explanation of supporting characters in movies [...]. Sometimes you see a supporting character that works, sometimes they don't work. The successful ones are those that have the potential to be a leading character in a film that hasn't been made – that was the initial theory behind everything. And then the idea came to me to experiment with this by making several films in which you have the same set of characters, and the supporting characters in one film are the principal characters in another; to really examine the life elsewhere of these supporting characters.

The film-makers chosen by Sigma and Zentropa to direct were Andrea Arnold, Morag McKinnon and Mikkel Nørgaard, and the first Advance Party film to be released was Arnold's *Red Road* (2006). Set in the eponymous Glaswegian housing scheme in North Glasgow's Barnhill area, it's a potent drama of sexual revenge that David Martin-Jones describes as 'perhaps the clearest example so far of a Scottish art film being deliberately manufactured for the international film festival circuit'. It was a major success internationally, winning the Jury Prize at the 'Cannes Film Festival'. Its follow-up, McKinnon's *Donkeys*, only appeared in 2010, after a somewhat troubled gestation and (inevitable) circumvention of the established Advance Party rules. Writer Colin McLaren was drafted by McKinnon to work on the script while Andy Armour – in line to resume his role as Alfred from *Red Road* – was replaced by James Cosmo due to the original actor's ill-health. As McKinnon explains:

The interesting thing is that you [...] gravitate towards the characters you want to work with. With Andrea [Arnold], she knew she wanted to work with Jackie [in *Red Road*], and stories emerge from that very naturally. I went straight to Alfred because he's a liar, he's fallible, he's 64 and I wanted to do something with someone coming to the end of their life, having a health scare and really having to confront what their life was all about.

Donkeys is less an example of Scottish art cinema and more of a Solondzian black comedy with much of the humour coming from Alfred's bungling attempts at reconciling with his estranged family. While not garnering the widespread acclaim of *Red Road*, McKinnon's film did win its fair share of prizes, including a Scottish BAFTA award for Cosmo's performance – an undoubted career high.

At the time of writing, Danish director Mikkel Nørgaard is preparing the third Advance Party feature. Sigma, meanwhile, have already announced Advance Party II and a new set of rules, 'some creative and some production focused, devised by the film-makers themselves.' Whether or not Advance Party has had the far-reaching influence of Dogme 95 is open to question. It has, however, certainly contributed to putting Scotland once again firmly on the map as a world-class film-making nation – the city of Glasgow in particular – with productions of all shapes and sizes from across the globe finding that the country can be used for much more than backdrops for historical epics. ✣

Whether or not Advance Party has had the far-reaching influence of Dogme 95 is open to question. It has, however, certainly contributed to putting Scotland once again firmly on the map as a world-class film-making nation

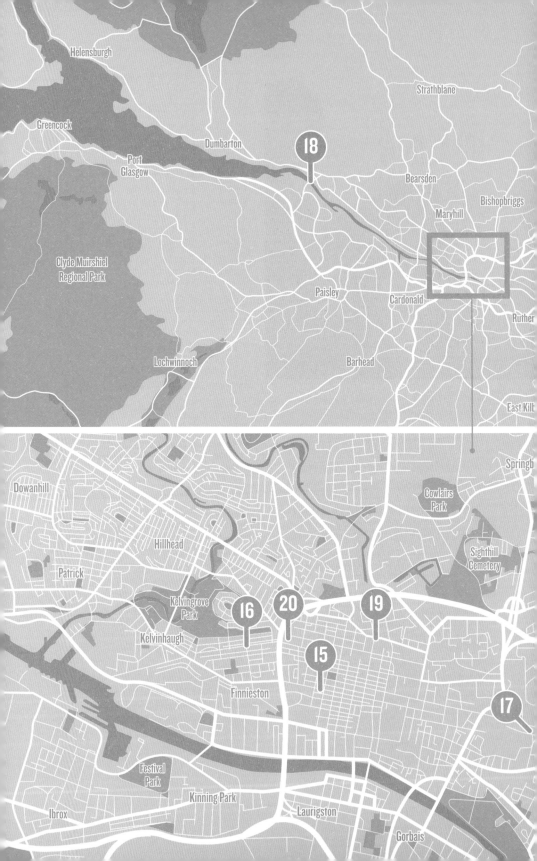

GLASGOW LOCATIONS

SCENES 15-20

maps are only to be taken as approximates

POSTMORTEM (1998)

LOCATION *St Vincent Street Church, 265 St Vincent Street, G2 7LA*

IT IS WELL REPORTED that the formidable architecture of Glasgow left such an impression on Christopher Nolan when location scouting for *The Dark Knight* that he returned to shoot parts of the sequel. But before Batman was let loose on the streets, Charlie Sheen was frequenting the Tolbooth Bar in Saltmarket and sprinting through Central Station as James McGregor, the burnt out LA detective who returns to his Scottish roots only to be drawn into the investigation of a serial killer. The Corinthian pillars of St Vincent Street Church become shorthand in this film for all that is unfathomable about human psychology. It also appears as a family snap on the wall of an asylum, ostensibly where the murderer's sister has been institutionalized. The church was designed by Alexander 'Greek' Thomson who combined classical influences with more unusual oriental references, as evidenced by the temple-like facade and its highly decorative clock tower. The film is not without Greek inspiration either: it comes in the form of a vague Oedipus complex where the murderer's anger towards his father for denying him the opportunity to be a 'pillar of the community' is redirected towards pretty middle-class women who remind him of his mother. In this scene, McGregor catches him latex-handed and gives chase, permitting a peek at the grand interior of the church, still a place of worship, if not a pillar of the community. The council once had plans to turn it into an attraction to rival Rennie Mackintosh's Scotland Street School but The Free Church is currently saving it from dereliction. •• ***Susan Robinson***

Photos © Lewis Smith

Directed by Albert Pyun
Scene description: The hunt for a serial killer closes in on the
sinister surroundings of St Vincent Street Church
Timecode for scene: 1:30:00 – 1:36:30

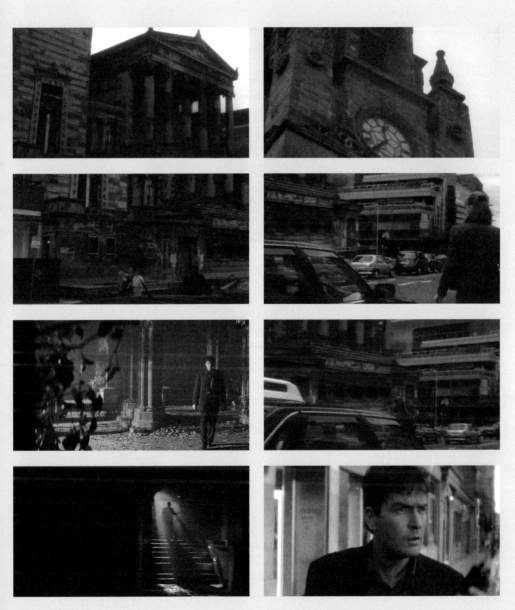

Images © 1998 Filmwerks

THE BIG TEASE (1999)

LOCATION *Mister Singh's, 149 Elderslie Street, G3 7JR*

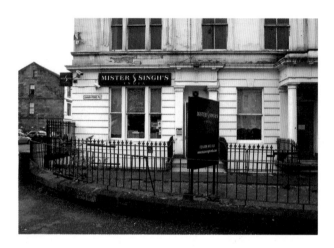

THE BIG TEASE STARS Glasgow native Craig Ferguson as Crawford Mackenzie, Glasgow's friendly (and flamboyant) local hairdresser extraordinaire. Crawford has been chopping locks in Glasgow for five years and the big fish is ready to cross the proverbial pond (the Atlantic Ocean) in search of an adventure. Upon discovering he has been invited to the World Hairdresser Federation's Golden Scissors competition in Los Angeles, he packs his tartan suitcase and takes off for tinsel town. Before upping sticks, however, Crawford buys a last round at the local curry shop. The same Glaswegian spirit is captured in Mister Singh's, a cornerstone of Glasgow's Indian cuisine. Located on the corner of Sauchiehall Street and Elderslie Street, the restaurant is a multicultural haven, as proud of Glasgow as Crawford himself. Its staff serve in kilts and the restaurant's entrance wall is proudly adorned with the striking image of a turbaned Sikh in full Scottish dress, complete with claymore. Here the restaurant plays host to Crawford's goodbye party and, fittingly, his eventual homecoming. Crawford's an everyman – friend to the old ladies for whom he sets weekly rollers, a collection of friends as flamboyant as he is, and the sharply-dressed staff. Rooted in community spirit, the people are as important as the architecture, and it is not talent but his spark of Weegie personality that paves Crawford's road to success. The image of the corner-shop restaurant as a meeting place for a community send-off embodies Glasgow's spirit of good food, good friends, mild manners and hot curries. ◆**Nicola Balkind**

Photo © Lewis Smith

Directed by Kevin Allen
Scene description: Crawford's bon voyage party at the local Indian restaurant
Timecode for scene: 0:05:00 – 0:06:04

Gareth Pritchard
(Friend)

Images © 1999 Warner Bros. Pictures

RATCATCHER (1999)

LOCATION *Scrubland behind Hunter Street, Dennistoun, G4*

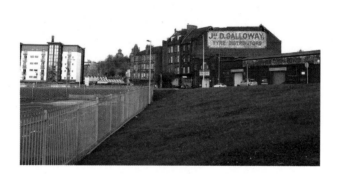

SET AMIDST THE SQUALOR and stench of the near-slum housing schemes of the city's East End during the binmen strike of 1973, Lynne Ramsay's directorial debut, *Ratcatcher*, is a haunting, impressionistic drama awash with a bold tapestry of symbolism, poetic imagery, narrative ambiguity and stark social realism. Screened in the 'Un Certain Regard' section of the 1999 'Cannes Film Festival', and winning Ramsay multiple awards at various film festivals, *Ratcatcher*'s painful, touching and occasionally amusing vision of the spiritually and economically deprived lives of its working-class protagonists is seen through the eyes of its troubled and introverted lead character, James (William Eadie). An outsider even among the local misfits, James, partly to blame for the drowning of a child at the film's outset, is guilt ridden, sensitive by nature and emotionally stifled by a fraught, oppressive home environment. In an early, catalytic scene, James meets the equally troubled Margaret-Anne (Leanne Mullen) by the canal whose murky waters play such a symbolic part of the film's elusive plot. Running through the bleak, inhospitable scrubland behind Hunter Street in Dennistoun, with a weather-beaten sign reading 'Jas D. Galloway. Tyre Distributor' visible in the background, the canal, like James and Margaret-Anne, contains many secrets beneath its outwardly calm surface. Margaret-Anne is both wary and intrigued by James, as he is of her. Their initial meeting sows the seeds for the mutual closeness they come to share, offering them respite, however fleeting, from the urban decay and casual cruelty around them. **Neil Mitchell**

Photo © Lewis Smith

Directed by Lynne Ramsay
Scene description: James meets Margaret-Anne
Timecode for scene: 0:18:36 – 0:21:46

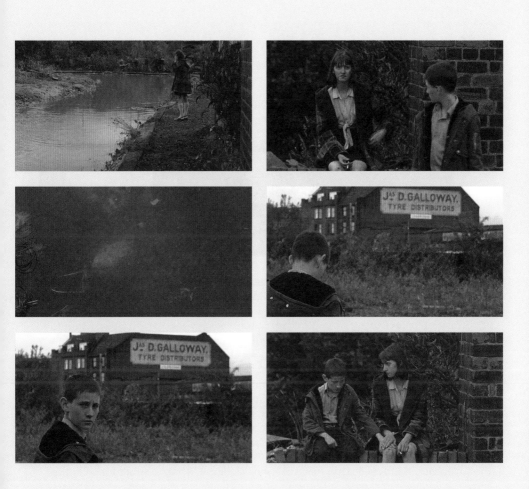

Images © 1999 Pathé Pictures International, BBC Films

BEAUTIFUL CREATURES (2000)

LOCATION *Erskine Bridge (A898), G60*

GREETED BY AN IMPOSING VIEW of the city below her, Dorothy (Susan Lynch) walks to the centre of the Erskine Bridge and makes an important phone call. 'If Brian's brother wants Brian back,' she begins briskly, 'he's going to have to pay money for him.' Against the roar of traffic from the A898, Dorothy appears to be making kidnapping demands – but as is often the case in Bill Eagles's black comedy, all is not quite what it seems. The person on the other end of the phone is Petula (Rachel Weisz), Dorothy's accomplice, here feigning as victim in the presence of a detective. Brian has not been kidnapped but accidentally killed after his abusive relationship with Petula came to a violent head. It is a scene which typifies the irreverent, bleak sense of humour of the film: like a Scottish *Thelma & Louise*, but exponentially darker. As Dorothy finishes her call, she's interrupted by a policeman, not there to foil her inadvertent criminal enterprise but to prevent a potential suicide. Sadly, he is right to be cautious: Erskine Bridge is something of a suicide hotspot, with as many as sixteen suicide attempts per year. Four telephone boxes, with adverts for the Samaritans, have been specially installed on the bridge to deter further attempts. The policeman's advice to Dorothy, however, is charmingly tactless. 'It's lovely,' she says, observing the magnificent view. 'It's no lovely when you're fishing them out of the water,' counters the copper. 'Away home and take an overdose.' ➥*John Nugent*

Photos © Alasdair Watson

Directed by Bill Eagles
Scene description: *Dorothy gives her demands over the phone*
Timecode for scene: *0:35:02 – 0:38:28*

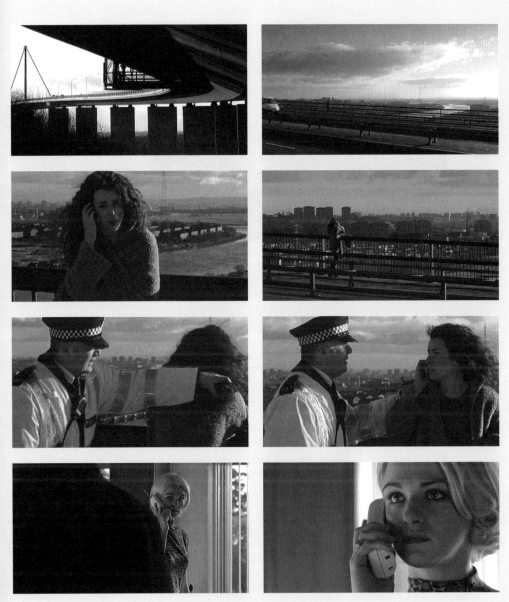

Images © 2000 DNA Films

THE HOUSE OF MIRTH (2000)

LOCATION

Theatre Royal, 282 Hope Street, Cowcaddens, G2 3QA

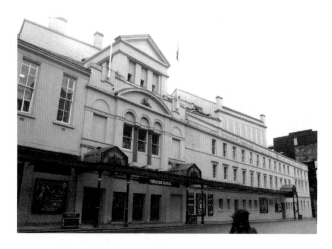

TERENCE DAVIES UTILIZED numerous locations in and around Glasgow to recreate the period detail of belle époque New York in his adaptation of the Edith Wharton novel. An important scene midway through the film shows social climber Lily Bart (Gillian Anderson) ascending the steps of the New York Opera House to the semi-diegetic strains of Mozart's *Così fan tutte*, dressed strikingly in red amid the monochromatic patrons arriving for the evening's performance. Davies used Kelvingrove Art Gallery and Museum for the brief entrance and staircase shots but moved to the sumptuous interior of the Theatre Royal for the main scene setting. It is here, as the audience settles, that Lily presents herself to society along with two male companions: Gus Trenor (Dan Ackroyd), a married man, and Sim Rosedale (Anthony LaPaglia), a wealthy Jewish suitor. Lily's benefactress aunt Julia (Eleanor Bron), seated in a box opposite Lily, is scandalized by the company her niece keeps, more so when she learns from Lily's cousin Grace (Jodhi May) that her beneficiary also has gambling debts. The orchestrated disapproving eye-play of the assembled social echelons force Lily into a staged retreat from her box before the opera has even begun. Davies lucked out with his location; a couple of years before filming the Theatre Royal, opened in 1867, received a lottery-funded makeover designed to restore its original decorative style. Consequently the fresh cherry red walls, turquoise seating and red and turquoise carpeting lent instant authenticity to the scene that expensive set dressing would have struggled to match. ➜*Jez Conolly*

Photo © Guy Phenix

Directed by Terence Davies
Scene description: Lily courts controversy at the opera
Timecode for scene: 0:40:31 – 0:44:47

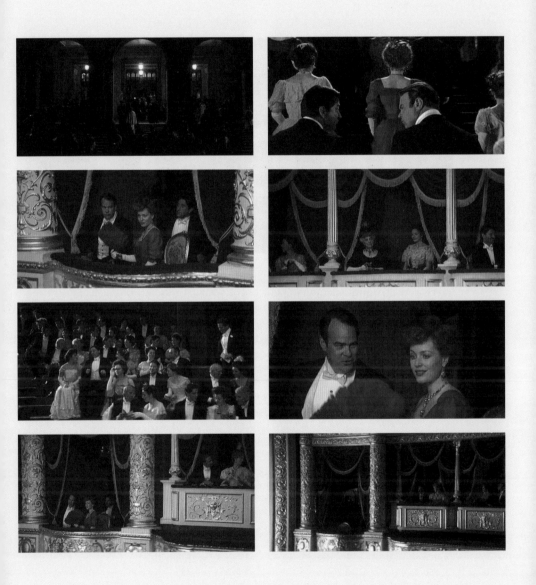

Images © 2000 Arts Council of England, Diaphana Films, FilmFour

LATE NIGHT SHOPPING (2001)

LOCATION *Variety Bar, 401 Sauchiehall Street, G2 3LG*

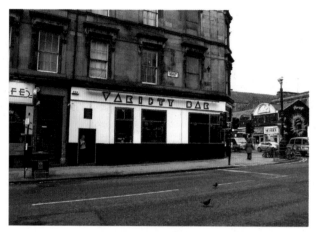

HOW DOES A DIRECTOR instantly confer the fast-paced, callow and undeniably one-dimensional nature of the early noughties; the decade of maxing out credit cards, ruthlessly leaving one job for another as the mood takes you, and applying pretty much the same logic to relationships? Simple: set your opening sequence in the flashiest late night diner you can find and let your protagonists do the talking. In *Late Night Shopping,* director Saul Metzstein adopts the Tarantino approach to characterization by encouraging the audience to act as voyeurs to episodes of post-work conversation and sly pick-up strategies. The four central characters, Sean (Luke de Woolfson), Vincent (James Lance), Jody (Kate Ashfield) and Lenny (Enzo Cilenti) are linked, almost exclusively, by the fact that they all work the night shift. To cope with the resulting displacement, they take up shop in the aforementioned cafe once their shift is over to vent and share experiences. Metzstein's Glasgow is one of neon lighting, designer coffees and plush diner booths with a surface of indisputable cool. Perhaps one of the most intriguing aspects of this set up is the urge, as a viewer, to search beneath the facade of both the place and the characters on-screen and delve into the hidden ugliness camouflaged by confidence and sheen. The superficial atmosphere created in this scene is impossible to ignore, relating an all-important sense of time and place in a near but irretrievable past. **↝Helen Cox**

Photos © Lewis Smith

Directed by Saul Metzstein
Scene description: Four friends meet in a bar and make a bet
Timecode for scene: 0:01:30 – 0:03:50

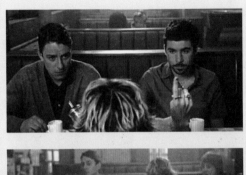

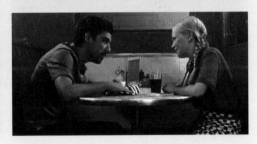

Images © 2001 FilmFour, Glasgow Film Office

GLASGOW'S KITCHEN SINK

Text by
DAVID
ARCHIBALD

The Cinema of Ken Loach and Peter Mullan

IN THEIR GLASGOW-SET FILMS, the locations utilized by the socially-committed film-makers Ken Loach and Peter Mullan contrast the former second city of the Empire's impoverished housing schemes with its more affluent, middle-class areas. They both also make extensive use of the green areas in the city and its environs as spaces for contemplation and reflection, either for their characters, or for their audiences.

This is evident, for instance, in Loach's first foray north of the border, *Riff-Raff* (1991), which, although set predominantly in London, follows Glaswegian building worker Stevie (Robert Carlyle) as he travels home for his mother's funeral. In this sequence, social and emotional loss are integrated as the funeral procession drives through a decaying housing scheme before the bereaved family scatters their loved one's ashes in a local tree-lined crematorium.

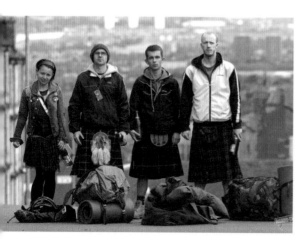

Carlyle also appears in *Carla's Song* (1996), playing bus driver George, who falls for a Nicaraguan dancer, the eponymous Carla, and the film tracks their journey from Glasgow to war-torn Nicaragua. *Carla's Song* marks the first of Loach's collaborations with Paul Laverty. Laverty was born in India and lives in Madrid, but he spent many years in Glasgow as a student, lawyer and political activist. Following a stint as a human rights adviser in Nicaragua, he returned to Glasgow and began drafting a script based on his experiences there. After initial correspondence and telephone conversations, Loach travelled to Glasgow for their first face-to-face meeting, indicative of the director's approach to 'always follow the writer'. A significant section of the film is shot in the city centre and West End bus routes on which George works, but we also witness his cramped domestic space in one of the city's housing schemes. This is contrasted with the open, rural space of Loch Lomond when George takes Carla on a day trip, a contrast also evident when the couple travels to Nicaragua in the second half of the film.

Loach and Laverty followed with *My Name is Joe* (1998), which features Peter Mullan as Joe, a recovering alcoholic. Again, the film contrasts the decaying, drug-strewn housing schemes in the north and east of the city with the housing in the more affluent West End: the former's metal-covered windows a far cry from the latter's stained-glass house doors. And urban experience is once more juxtaposed with rural Scotland: when Joe embarks on a coerced drug-run, he stops for a break at Glencoe, sees a piper playing 'Scotland the Brave' and comments, wryly,

Above © 2002 Alta Films, Road Movies Filmproduktion, Sixteen Films
Opposite © 2010 Entertainment One, Sixteen Films, Why Not Productions

'Bonnie Scotland, right enough.' The contrast between Scotland's landscape and its inhabitants' lived urban experience is also evident in *Sweet Sixteen* (2002), which is filmed in Port Glasgow and Greenock, within twenty miles of Glasgow.

Ae Fond Kiss... (2004) marks something of a departure for Loach and Laverty in that its focus is on middle-class, affluent characters. Tackling the complexities of racism and sectarianism through the troubled romantic relationship between Casim, a Scots-Asian accountant and Riosin, a teacher of Irish Catholic descent, *Ae Fond Kiss...* is set primarily in Glasgow's well-heeled districts and the characters socialize in expensive wine bars rather than, for instance, the smoke-filled snooker club represented in *My Name is Joe*. The city's parks remain spaces for reflection, exemplified in the scene in which Casim and his brother discuss their plans as they look down from an expensive city-centre flat over Glasgow Green.

Tickets (2005) continues Loach and Laverty's association with Glasgow. A portmanteau piece directed by Loach, Abbas Kiarostami and Emanno Olmi, Loach's concluding segment is not set in Glasgow but, rather, follows three fans of Glasgow Celtic Football Club travelling to Rome to watch their team.

Loach and Laverty's most recent film, *The Angels' Share* (2012) focuses on a group of unemployed youngsters from Glasgow's East End, but was shot in various Scottish locations. The difference in the city's housing stock once again highlights the city's social divisions and the juxtaposition between city and rural life is brought into even greater relief when the kilted-up youngsters travel to an idyllic whisky distillery in Tain in the north of Scotland.

Born in Peterhead, Peter Mullan has lived most of his life in the city. A graduate of the University of Glasgow's Drama Department, he wrote and directed three shorts – *Close* (1993), *Good Day for the Bad Guys* (1995) and *Fridge* (1995) – all of which are set in Glasgow. In these early works the cinematic differences with Loach emerge: *Close*, for instance, is shot in a Glasgow tenement stairwell but features significant expressionist influences.

These differences become more manifest in Mullan's directorial feature debut, *Orphans* (1998), a comic-tragic account of the lives of four adult, working-class siblings on the eve of their mother's funeral. *Orphans* is set predominantly at night, with Glasgow transformed into a nightmarish underworld in which the characters traverse different parts of the city; pubs and karaoke bars, the carnival, massage parlours. When one character, Michael, floats down the River Clyde in his blood-soaked clothing, the cranes of the city's once great but now barely functioning shipyards come into view, thereby, as with the funeral scene in *Riff-Raff*, connecting familial loss with societal loss, but with an experimental cinematic style. This loss is spectacularly reinforced when the roof of the church in which the siblings' mother is lying is blown off in a storm.

Mullan's next Glasgow-based feature, *Neds* (2010), explores 1970s knife- and razor-wielding gang culture. The film's main character, John McGill, briefly befriends a young middle-class friend; his new associate's home seems almost palatial when contrasted with John's excellently recreated working-class scheme. In contrast to Loach's work, in *Neds* the city's green spaces are more likely to be locations for gang fights. But these sequences are also evidence of Mullan's experimental film-making style, whether that be in an alcohol-induced, dream-like fight with Christ or a surreal closing scene in which the characters walk through a den of lions. In that, these sequences encourage reflection on both the lives of the characters, but, unlike Loach's work, also on the constructed nature of the films themselves. ✦

Both directors make extensive use of the green areas in the city and its environs as spaces for contemplation and reflection, either for their characters, or for their audiences.

GLASGOW LOCATIONS

SCENES 21-26

maps are only to be taken as approximates

THREE WAYS OF LOVE/ PYAAR ISHQ AUR MOHABBAT (2001)

University of Glasgow, University Avenue, G12 8QQ

IN THIS RARE BOLLYWOOD FORAY to the United Kingdom, beautiful Mumbai student Isha (Kirti Reddy) wins a scholarship to study medicine at the University of Glasgow. Her specialism is – of course – the heart, which she studies inside and outside the classroom. From the moment Isha's plane hits the tarmac at Prestwick airport it is clear that Pyaar Ishq aur Mohabbat is no askance Indian eye on No Mean City. This is less east meets west, more east goes west, as director Rajiv Rai uses Glasgow's ancient structures and eerily deserted streets as a playground for a frothy tale of love, amour and romance – the three ways of love of the title. Three is the magic number here as a trio of suitors vie for Isha's affections. There's Taj (Aftab Shivdasani), the goofy son of a wealthy family friend at whose country pile Isha is lodging; Yash (Sunil Shetty), the business tycoon who is financing her scholarship; and Gaurav (Arjun Rampal), a male model who Yash sends to Scotland in a convoluted scheme to push Isha into his cold corporate arms. It is on Isha's first tour of her new seat of learning that she meets Gaurav, who is posing as the university's handyman. Yash's Machiavellian plan is set in motion with a piece of theatre that sees a hired stooge feign a fall from some scaffolding and a dislocated shoulder, allowing a passing Gaurav to heroically pop the injured man's bone back into place. Isha, a star medical scholar, falls for the ruse and for Gaurav, proving that love really is blind. **↝Jamie Dunn**

Photos © Alasdair Watson

Directed by Rajiv Rai
Scene description: Isha meets Gaurav on a tour of the University of Glasgow
Timecode for scene: 0:41:45 – 0:46:25

Images © 2001 Trimurti Films Pvt. Ltd.

STRICTLY SINATRA (2001)

LOCATION *Salkeld Street, G5 8HE (train tracks running south from Central Station)*

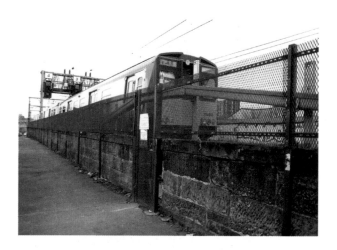

IN PETER CAPALDI'S under-appreciated 2001 drama, Ian Hart stars as Sinatra-obsessed club singer Toni Cocozza, who gets his first break when his act is seen and appreciated by some local Glasgow gangsters, including Chisolm (Brian Cox), who tells an awe-struck Toni that he once met Ol' Blue Eyes himself. Granted access to an exclusive casino nightclub, Toni has the night of his life when he meets gorgeous cigarette girl Irene (Kelly Macdonald), is enthusiastically introduced around the club as 'the next big thing', and has his photo taken with a veritable who's-who of Glasgow nightlife. The montage of old-fashioned flashbulbs then fades away to reveal Toni happily walking along the South Side's Salkeld Street the next day, his head still full of the night before. Imagining that he is now famous, he cheerfully greets the first person he sees. As a train trundles into the frame behind him, Toni is brought back down to earth with a thump as an extremely red-nosed child asks him if he can spare any change, accepts his money and then calls him a poof as a parting shot. The juxtaposition of Sinatra-style glitz and glamour and harsh Glasgow reality is a cleverly executed theme that runs throughout the film and the Salkeld Street location is entirely appropriate, since it is across the tracks from several former entertainment palaces, including a home of Hollywood dreams, the former New Bedford Picture House. •»*Matthew Turner*

Photo © Lewis Smith

Directed by peter Capaldi
Scene description: Toni Cocozza is brought back down to earth
Timecode for scene: 0:11:44 – 0:12:24

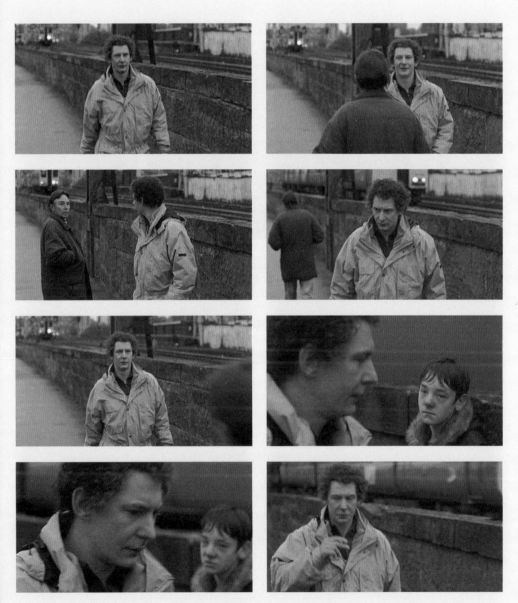

Images © 2001 DNA Pictures International, Arts Council of England

SWEET SIXTEEN (2002)

LOCATION *Cloch Caravans Holiday Park, Cloch Road, Gourock, PA19 1BA*

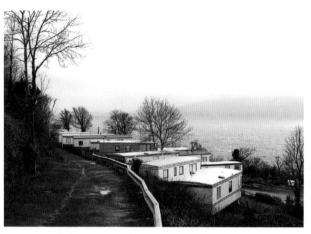

INEVITABILITY HANGS like a foul odour over the characters in *Sweet Sixteen*, however well intentioned they may be. Fifteen year-old Liam (Martin Compston, astonishing in his acting debut) lives in the formerly thriving ship building town of Greenock and spends more time visiting his mother in prison than he does at school. He rides with his pal Pinball (William Ruane) who, having 'borrowed' a Mercedes for a joyride, drives them to a local caravan park where Liam has a dream of buying a mobile home for him and his mother to live in. She is just ten weeks away from release, right around the time when Liam will turn 16. With its spectacular views across the Firth of Clyde to the hills of Argyll and the Trossachs, the freedom the caravan represents is a world away from the drugs and violence of his everyday life. Its rooms, though small, would be like those of a palace to his 'cooped up' mother. Meanwhile Liam and Pinball speculate and fantasize about the days and nights of fishing and drinking they plan to enjoy there. But reality has a way of encroaching into such reverie and puncturing dreams of liberty. Liam has funded the caravan with the sale of a quantity of smack stolen from his abusive and despised stepfather, bringing him to the attention of the local kingpin who recognizes his intelligence and resourcefulness. He is soon drawn farther into the criminal activities that he initially seemed smart enough to be able to escape. ❖*Paul Greenwood*

Photos © Alasdair Watson

Directed by ken Loach
Scene description: Liam dreams of a new life for his imprisoned mother
Timecode for scene: 0:20:07 – 0:21:42

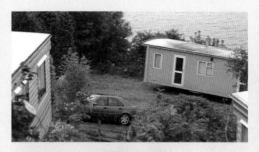

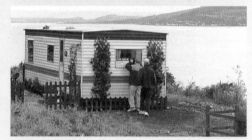
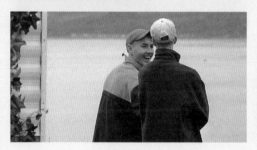
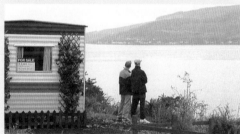

Images © 2002 Alta Films, Road Movies Filmproduktion, Sixteen Films

WILBUR WANTS TO KILL HIMSELF (2002)

LOCATION / *Glasgow Necropolis, 70 Cathedral Square, G4 0UZ*

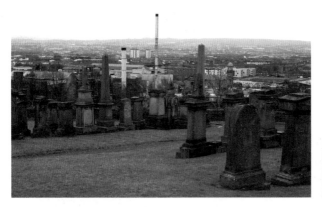

EARLY ON IN LONE SCHERFIG'S *Wilbur Wants to Kill Himself*, brothers Harbour (Adrian Rawlins) and the stubbornly suicidal Wilbur (Jamie Sives) visit the grave of their recently deceased father on a chill, overcast day. Both their parents are buried in the Glasgow Necropolis, a vast Victorian cemetery situated on a hillside – as the architectural historian Professor James Stevens Curl would have it, 'literally a city of the dead'. A visibly uncomfortable Wilbur enquires as to where their mother is buried and is directed to the site, about which Harbour tenderly explains, 'Father wanted her to be able to see the shop, if she leant forwards a little.' Wilbur repeats Harbour's words back with incredulity, to which he replies, 'He wasn't feeling too well at the time.' The Necropolis looms benevolently over Glasgow; 50,000 people are buried in its grounds and it features over 3,000 monuments. Glasgow is a city about which the Glaswegian comedian and actor Billy Connolly has said, 'It doesn't care much for the living, but it really looks after the dead.' The nature of the location has further poignancy for the brothers, as the Grim Reaper seems to constantly be calling to the wiry, depressed Wilbur, before making a cruel move for the life of the more content and nurturing Harbour. It is apposite that a film so peppered with death – which, in fact, exists entirely in its shadow – should be set in a city where the dead so conspicuously keep watch over the living. ➜*Emma Simmonds*

Photos © Lewis Smith

Directed by Lone Scherfig

Scene description: Wilbur and Harbour visit their parents' hilltop graves

Timecode for scene: 0:08:24 – 0:09:57

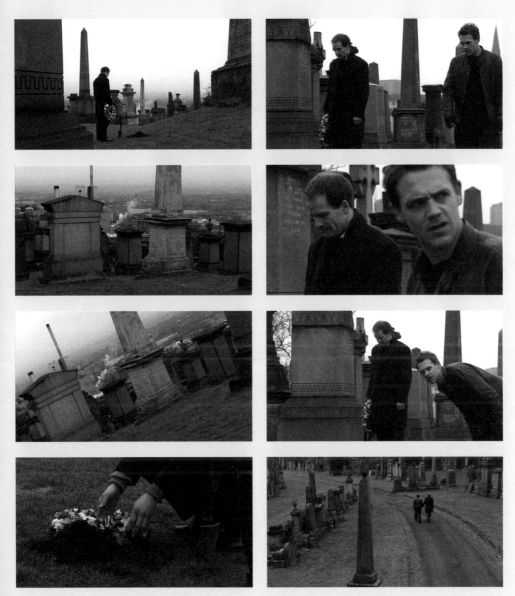

Images © 2002 Zentropa Entertainments 6, Wilbur Ltd.

YEH HAI JALWA (2002)

George Square, Glasgow City Centre, G2 1DU

WHEN RAJU (SALMAN KHAN) arrives in London, he is welcomed by a mysterious stranger who seeks to remind him that, wherever he is in the world, he will always be an Indian. This being a Bollywood film, the stranger delivers his message not with a quiet chat but with a spectacular song and dance routine in a public square. Although not named as such, the square is clearly intended to be Trafalgar Square: the entire point of the song is that it takes place in a historic location in the heart of London, where, regardless of how English the surroundings may be, a true Indian will always retain his identity. However, as anyone who has ever seen Trafalgar Square can tell, the scene was filmed somewhere very different – and it is clear to anyone who has ever visited Glasgow's George Square where that 'it' was. Throughout the film, parts of Edinburgh and Glasgow stand in for London, but none quite so obviously as here: the backdrop for much of the routine is the unmistakable Glasgow City Hall. While this may seem absurd to British eyes, it is important to remember that *Yeh Hai Jalwa* is an Indian film aimed at Indian audiences and, just as British filmgoers may not be able to tell one Indian city from another in the space of a single song, for Indian viewers the sight of British buildings, billboards and a red double-decker bus may be enough to suggest that the location onscreen really is London. **↠Scott Jordan Harris**

Photo © Guy Phenix

Directed by David Dhawan
Scene description: An Indian in London... in Glasgow
Timecode for scene: 0:16:59 – 0:22:35

Images © 2002 M.K.D. Films Combine

AMERICAN COUSINS (2003)

229 London Road, Glasgow, G40 1PE

GENTLE CAFE OWNER Roberto (Gerald Lepkowski) welcomes his American cousins Settimo and Gino (Dan Hedaya and Danny Nucci) to stay with him in Glasgow for a few days, unaware that his newfound family members are New Jersey mob men sent to hide out in Scotland following some dealings with the Ukrainian mafia. As their respective 'family businesses' converge, it is a catalyst for Roberto to rise to meet some of the challenges in his own life – particularly his unspoken love for waitress Alice (Shirley Henderson), which comes under threat with the arrival of the handsome Gino. The fish frying scene is almost a duel for her affections. While Gino tries to prove it is a task any idiot can undertake, it is the only thing Roberto has ever really known how to do. Though the cafe interior was shot on a set in Govan, the entrance facade was built into a unit on London Road that forms part of the famous – and occasionally infamous – Barras Market, and is actually home to a motoring company. Screenwriter Sergio Casci drew on his own family background and those of the hordes of pre- and post-war Italian immigrants who opened cafes in Glasgow and the surrounding areas and named it Café del Rio after the one his grandfather opened on Bridge Street in 1937. As *American Cousins* demonstrates, an Italian 'chippy' in Glasgow is still as much a part of the city's identity as Irn-Bru or the Old Firm.
⟿Paul Greenwood

Photo © Lewis Smith

Directed by Don Coutts
Scene description: Roberto teaches his cousins the art of fish frying
Timecode for scene: 0:20:41 – 0:24:44

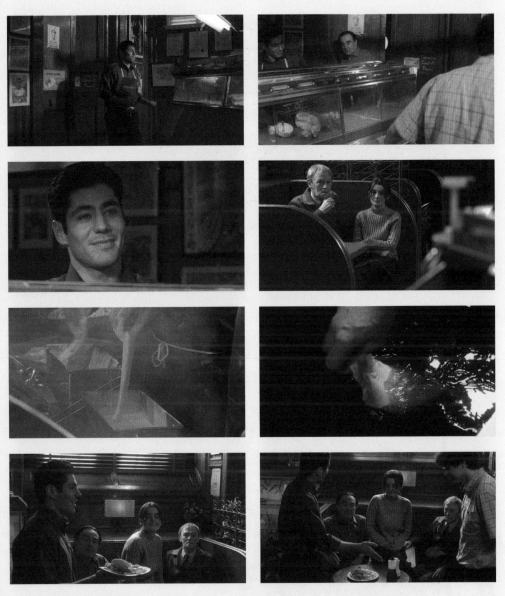

Images © 2003 Little Wing Films

DEAR GREEN SHOOTS

Text by
SEAN
WELSH

Underground Film-Making in Glasgow

FROM ONE PERSPECTIVE, Glasgow currently seems to be going through an incredibly clement spell when it comes to film-making. With major American productions setting up shop in the city's streets and internationally famous faces appearing here there and everywhere, the city is certainly enjoying the warmth that Hollywood's – usually fickle – glance provides. Glasgow in the twenty-first century has a proven versatility as a location that is so far unmatched by the imaginative diversity of its locally-sourced narratives. Paucity of funding and a comparatively low production output means films that claim to feature the city 'as it is' are few and far between. Of late, however, there are signs that Glasgow could begin to flourish as a cinematic landscape on its own diverse merits.

In common with the big-budget productions alighting on the Dear Green Place, production companies based in the city have found that, with some creative concessions, Glasgow can easily accommodate smaller-scale productions whose narratives play out in distant lands. Glaswegian writer Mark Millar's comic book properties have

been turned into big budget Hollywood films, spurring his recent project to found a production company, MillarWorld, in the city. He points out that low-budget American successes like *Paranormal Activity* (2007) could just as easily have been made in Glasgow. Local production house Black Camel Pictures have recently proved as much with the likes of *Outpost* (2008) and *Legacy* (2010), relatively low-budget films nominally set in Eastern Europe and New York respectively, but filmed locally. Glasgow, however, has long hosted productions shooting interiors that could be anywhere – even the definitively Edinburgh-set *Trainspotting* (1996) shot much interior work in Glasgow.

In contrast, high profile films that are identifiably locally set and produced tend to be focused on the past and take a 'socially-realistic' view of the city. Such views conform to certain cultural expectations but are often grossly reductive. Peter Mullan's *Neds* (2010) is the latest example of an ongoing preoccupation with the city's dark and violent side, as previously assayed in *A Sense of Freedom* (1985), *The Big Man* (1990) and *Small Faces* (1996) among many others. Meanwhile, Duncan Petrie's description of the Glasgow of Lynn Ramsey's *Ratcatcher* (1999) as 'the image of a shabby and neglected proletarian city, a backdrop to unrealised dreams and wasted lives', is still applicable to a conspicuous number of the city's films.

One problem facing the small number of Glaswegian films that are produced is that the weight of expectation on them is exponentially and unfairly increased. If successful, its content will likely dictate what is henceforth perceived to be bankable or exportable and will, simultaneously, become totemic of everything that is right or wrong with Scottish film-making. With the relatively small amount of funding available to film-makers, this puts them in an almost impossible position. Film-makers may attempt to

Above © 2011 Sigma Films
Opposite © 1995 Billy MacKinnon, BBC, Skyline Films

find support to produce work that derives from a previously successful work, but they face an uphill struggle in attempting to produce something out of the ordinary with very little resources. Either way, their work will then be vigorously criticized in order to be ratified (or more often, not) as a 'worthwhile' Glaswegian film.

There is, however, a deepening desire to drag modern Glasgow into the cinematic light, away from violence and deprivation and towards a more diverse imaginative landscape. David Mackenzie's *Perfect Sense* (2011) perhaps represents the most imaginative recent use of the city. However, in a lineage of sorts with Bernard Tavernier's *Death Watch* (1980), also a sci-fi film set in the city, Mackenzie neither conceals nor foregrounds the city's visual identity. Glaswegian artist Douglas Gordon's 1998 artwork *Empire* features prominently, though subtly, in *Perfect Sense*. The work, a neon sign frequently spotted in a street where much of the action takes place, directly references the Empire Hotel

> **Glasgow in the twenty-first century has a proven versatility as a location that is so far unmatched by the imaginative diversity of its locally-sourced narratives.**

featured in Alfred Hitchcock's *Vertigo* (1958) and, more obliquely, Glasgow's history as the second city of the British Empire in its tobacco-trading heyday. Its presence in *Perfect Sense* is a wonderful example of both the cultural and historical richness of the city, a subtext present though rarely overtly acknowledged in screen representations of Glasgow.

Local director Carter Ferguson's *Fast Romance* (2011) is more self-conscious in its desire to connect with and resuscitate a facet of local character championed by Bill Forsyth in films like *Gregory's Girl* (1981) and *Comfort and Joy* (1984). A light ensemble comedy set in contemporary Glasgow, *Fast Romance* pays homage to Forsyth's films explicitly, reusing locations (particularly a bridge in nearby Cumbernauld, featured in *Gregory's Girl*), and casting some of the same actors. More importantly, perhaps, the tone of the film locates it in a different, sunnier Glasgow.

Billy Samson and Gavin Mitchell's *Death of the Mod Dream* (2012), an episodic, blackly comic, semi-psychedelic musical – like a Scottish No-Wave film by way of Roy Andersson – was filmed on a budget of around £250, most of which went on travel costs and batteries for the basic Flip camera on which it was filmed. Key interiors were filmed in Glasgow flats while filming also took place in Edinburgh, London and Amsterdam.

Fraser Coull's *Night Is Day* (2012), a superhero movie firmly located in Glasgow, was produced on a slightly grander scale, but paid for with the still-miniscule budget of £4,500 and cast and crew hired on a percentage profit share in lieu of payment. With support from Glasgow City Council, Coull was able to make extensive use of the Botanic Gardens in the city's West End. The director said, 'We're not a wasteland, we're a thriving city with wonderfully talented and friendly people. That's the Glasgow I want to show.'

John McKay's recently announced *Not Another Happy Ending* (2012) purports to exploit a hitherto untapped vein of Glaswegian middle-class romantic comedy, while musician Stuart Murdoch's long-gestating film *God Help The Girl* looks certain to embody the singular vision of the city and its occupants that Murdoch's band Belle & Sebastian has popularized worldwide. Mark Millar has claimed that 'we are limited only by our imagination', and, if nothing else, Glasgow still remains a city ripe with much untapped cinematic potential. ✣

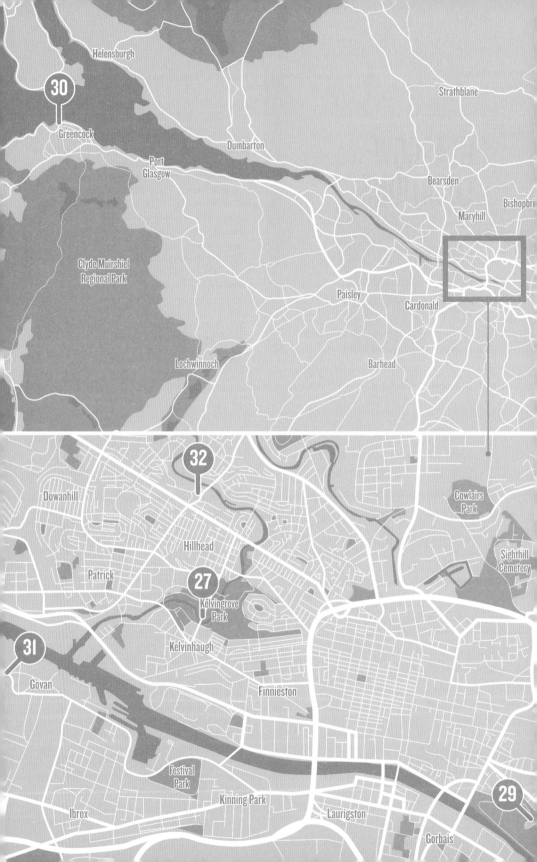

GLASGOW LOCATIONS

SCENES 27-32

maps are only to be taken as approximates

SWEET DREAMS/SKAGERRAK (2003)

Kelvingrove Park, looking over to Kelvingrove Art Gallery and Museum, Argyle Street, G3 8AG

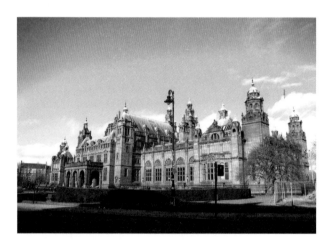

ONE OF TWO PALATIAL BUILDINGS to feature in this film, Kelvingrove Art Gallery and Museum provides the background for a heart-to-heart. The other, Arniston House, rather closer to Edinburgh than Glasgow, represents the decline of an aristocratic family who desperately bribe Marie (Iben Hjejle) to act as a surrogate to ensure an heir. The film's Danish title translates as 'broken ground' and this is also the peculiar name of the backstreet garage owned by Sophie's late friend Marie's dead lover, Ken. As if this was not convoluted enough, wheelchair-bound Ian (Martin Henderson) pretends to be Ken in order to protect the *in utero* investment of his wealthy employers. This black-tinted romantic comedy is perhaps a humorous exercise in what one vet and three Glaswegian mechanics – especially if they are in the size, shape and thickness of Ewen Bremner, Gary Lewis and Simon McBurney – will do to protect a pretty, pregnant Danish woman. Glasgow's rough edges provide a suitably urban environment for deception and mistaken identities. Meanwhile, its more gentrified quarters are a green space in which the stooges, Marie and Ian, are able to investigate their true feelings for one another. There is a myth that Kelvingrove was built back to front, as the main entrance is from Kelvingrove Park rather than Argyle Street, which is the route most visitors take. However inauspicious topsy-turvy origins may seem, both in life and in the film, misapprehensions have pleasing, if slightly eccentric, consequences. •**Susan Robinson**

Photo © Alasdair Watson

Directed by Søren Kragh-Jacobsen
Scene description: Surrogate mother Marie talks to 'Ken'
about Sophie, her best friend and his former lover
Timecode for scene: 1:04:00 – 1:05:45

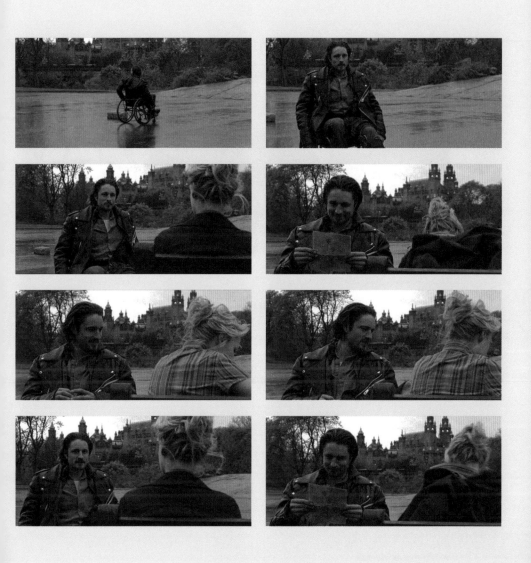

Images © 2003 Nimbus Film

YOUNG ADAM (2003)

LOCATION *The Forth and Clyde Canal, between the Clevedon Road bridge and Lock 26*

JOE (EWAN MCGREGOR) is an amoral drifter working, and living, aboard a canal barge owned by Ella Gault (Tilda Swinton) and run by her husband Les (Peter Mullan). Little does Les know that his lodger is a sexual predator who has already killed one girlfriend – albeit accidentally – and has now embarked on a tempestuous affair with Ella. Still, the hard work of ferrying goods across Scotland goes on – and dangerous work it is, too, as the Gaults' son Jim (Jack McElhone) learns when he falls overboard. Fortunately, Joe is around to dive in and save him from being hit by another passing barge. Ironically, a later flashback reveals that Joe loathed the kid ('I spend almost every moment wanting to kick him over the side'). Has the affair with Ella softened his resolve? Or – more likely – does Joe simply live in the moment, his mood and morals as changeable as a canal's water level? Adapted from Alexander Trocchi's 1957 avant-garde novel, this is an authentic portrait of barge life at the fag-end of the canals' heyday: still a booming business thanks to post-war fuel rationing, but soon to be superseded by the motorways' faster, more efficient transportation. Sure enough, Scotland's main arterial route, the Forth and Clyde Canal, was closed in 1963. After decades of disuse, a restoration effort began in 2000, enabling director David Mackenzie to film on the real-life canal. Today the Forth and Clyde has been restored to its former glory.
⇝ Simon Kinnear

Photos © Lewis Smith

Directed by David Mackenzie
Scene description: A barge hand rescues his boss's son from drowning
Timecode for scene: 0:24:56 – 0:26:17

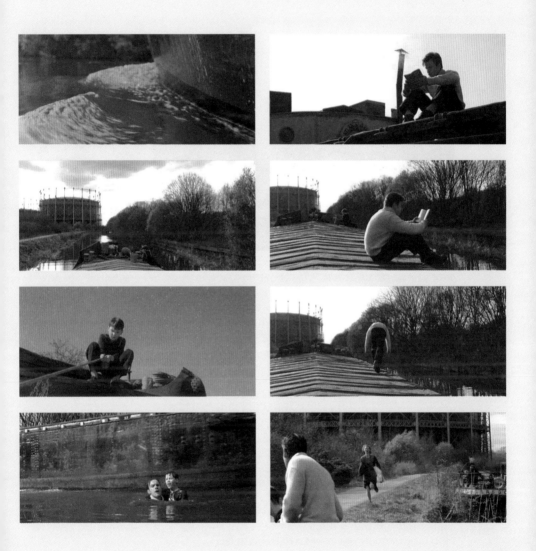

Images © 2003 Scottish Screen, Recorded Picture Company (RPC), Studio Canal

AE FOND KISS... (2004)

People's Palace and Winter Gardens, Glasgow Green, G40 1AT

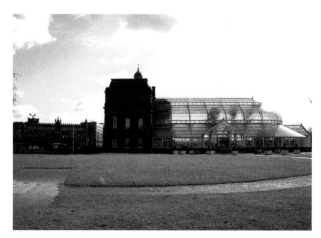

THE TITLE OF LOACH'S FILM about race, identity and cross-cultural romance derives from a Robert Burns poem in which the poet laments the loss of his beloved, the fond kiss being their last before parting. The yuppie apartment balcony in this scene overlooks Glasgow Green, the oldest public space in the city, and home since the nineteenth century of the People's Palace – now Glasgow's social history museum, and the Winter Gardens, a Victorian glasshouse. Despite the Romeo and Juliet-style storyline this balcony scene is short on romance. Hamid (Shy Ramsan) is trying to persuade his friend Casim (Atta Yaqub), an ambitious young DJ at one of Glasgow's coolest venues, out of his romance with Roisin (Eva Birthistle), a Catholic, and instead follow the path towards an arranged marriage with his cousin. He reminds Casim about the nearby mosque and the tradition that it represents: 'Shag who you want to shag, but don't fuck up your whole family.' Glasgow provides Casim with an array of lifestyle choices – DJ, entrepreneur – and entices with the trappings of western culture. Yet second-generation Muslims like Casim have to negotiate these choices and enticements amid the traditions of their families and culture. In a film that enables us to engage and empathize with these conflicting cultural pressures, the balcony conversation marks a critical point in that process of choice. **Caroline Whelan**

Photos © Lewis Smith

Directed by ken Loach

**Scene description: Casim and Hamid discuss girlfriends
and arranged marriage on a yuppie apartment balcony
Timecode for scene: 0:47:01 – 0:48:18**

Images © 2004 Bianca Film, Cinéart, Glasgow Film Office

DEAR FRANKIE (2002)

Battery Park, Gourock, PA16

DESPITE FEATURING SEVERAL of the same locations, *Dear Frankie* is a
world away from the grim realities of *Sweet Sixteen* (Ken Loach, 2002). This
heart-warming drama is told from the point of view of 9-year-old Frankie
(Jack McElhone). Having not seen his real father – whose abuse was the cause
of his deafness – since he was a baby, Frankie believes his father's absence
is a result of his job rather than anything more sinister. His mother (Emily
Mortimer) has been forging a series of letters purporting to be from his father
as he sails around the world, a fantasy that Frankie has been happily playing
along with as an antidote to his loneliness and isolation as he too moves from
town to town with his mother. But as he gets older and more curious, her lies
no longer stand up and she is forced to enlist a stranger (Gerard Butler) to pose
as 'Davie'. Frankie, having just met 'Davie', takes him to Battery Park – a local
football park at Gourock Bay – to meet his classmate, as much nemesis as
friend, who has bet him that there is no such person. The views of Kilcreggen
across the water are mere whispers of the global horizon Frankie believes his
father pursues. Fans of *Dear Frankie* can go on organized tours of the locations
and, in a pleasing piece of synergy, the film's world premiere at the 'Tribeca
Film Festival' in New York took place in the city's area of the same name –
Battery Park. **↝Paul Greenwood**

Photo © Alasdair Watson

Directed by Shona Auerbach
Scene description: *Frankie proves to his classmate that his father is real*
Timecode for scene: *0:49:49 – 0:50:51*

Images © 2004 Scorpio Films

ON A CLEAR DAY (2005)

LOCATION

BAE Systems Govan Shipyard, 1048 Govan Road, Govan, Glasgow, G51 4XP. (Views are also available from the other side of the Clyde at Meadowside Quay Walk, G11 6AW.)

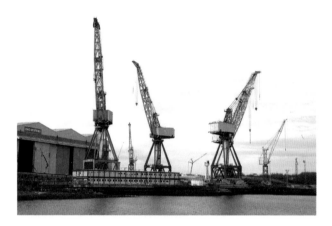

FEW FILMS SET IN GLASGOW can avoid at least one shot of the many towering cranes that line the banks of the River Clyde. Shipbuilding is deeply ingrained in the DNA of the city and its post-industrial decline continues to be felt sharply, as dramatized in Gaby Dellal's light-hearted drama about an unemployed former ship-worker who attempts to swim across the English Channel. Much like the rest of the film, *On A Clear Day*'s opening scenes are profoundly bittersweet. Excitable crowds gather at a shipyard to witness the launch of a new ship, and the atmosphere is palpable. As champagne breaks on the ship's bow amidst balloons and confetti, Frank (Peter Mullan) is quietly clearing his office. Along with hundreds of his fellow workers, this ship will be their last as the spectre of mass redundancies looms large. Frank's discontentment from being unemployed for the first time in three decades ultimately provides the catalyst for his life-affirming swim. The story has echoes of reality: in 2000, BAE Systems announced several hundred job losses in the Govan shipyard where this scene was filmed – and with more country-wide redundancies recently threatened, British manufacturing remains in a constant state of flux. The ship in this scene, meanwhile, was filmed at a real life launch, that of RFA Mounts Bay, a landing ship of the Royal Fleet Auxiliary. The launch did not go as smoothly as the film suggested – the ship sustained minor damage after becoming entangled in chains. The film-makers wisely chose not to include this mishap in their edit. **⟶John Nugent**

Photo © Lewis Smith

Directed by Gaby Dellal

Scene description: A newly-built ship is launched from the docks

Timecode for scene: 0:01:41 – 0:05:14

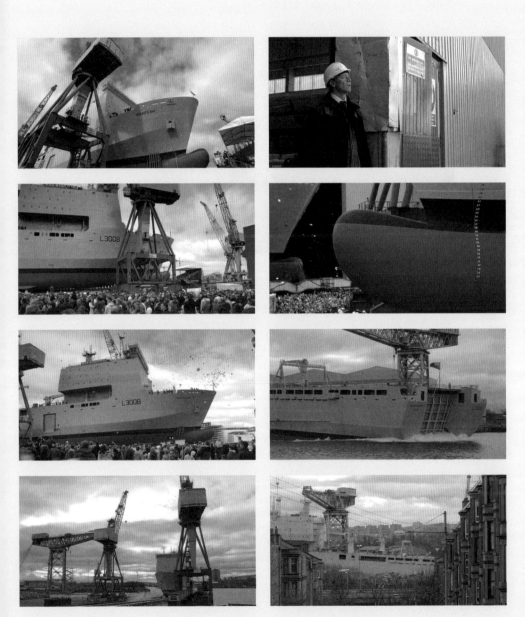

Images © 2005 Forthcoming Productions, InFilm Productions

UNLEASHED AKA DANNY THE DOG (2005)

LOCATION

Kibble Palace, The Glasgow Botanic Gardens, 730 Great Western Road, G12 0UE

UNLEASHED IS UNUSUAL in many ways. For one, it is a martial arts movie set in Scotland. For another, it takes place almost entirely in Glasgow and yet features hardly a single Glaswegian accent: it stars those well-known Scotsmen Morgan Freeman, Bob Hoskins and Jet Li. Hoskins plays a crime boss who extorts money from local businessmen by threatening them with 'Danny the Dog', the mentally handicapped killing machine he keeps locked in cage. When Danny escapes, he is taken in by an American expat (Freeman) and begins to lead something approaching an ordinary life. Hearing that Glasgow's Botanic Gardens (one of the most popular tourist attractions in the city), and specifically Kibble Palace (one of the most famous glass structures in Britain), appear in a Jet Li film, one might suppose them to be the site of a high-kicking, glass-shattering showdown. But in fact the opposite is true. The short trip Danny and his adoptive family take to the Botanic Gardens represents the same thing to them it would to us: a pleasant outing to a place filled with beauty both natural and man-made. Astonishingly, Kibble Palace was built, during the 1860s and 1870s, as an extension to a private conservatory. In 1872, its owner, John Kibble, had it dismantled and moved from his home in Coulport to its present site. Since then, it has become the perfect postcard image of Glasgow – which is partly why Danny and his new family take such care posing for a photograph there. **➥Scott Jordan Harris**

Photo © Alasdair Watson

Directed by Louis Letterier
Scene description: A trip to Glasgow's Garden spot
Timecode for scene: 0:47:45 – 0:48:02

Images © 2005 Europa Corp., Danny the Dog Prods Ltd., TFI Films Production

GLASGOW

Text by
NICOLA
BALKIND

Hollywood's Film Set

IN HIS BOOK *Scotland: Global Cinema* (2009), Scottish film academic David Martin-Jones takes care to distinguish between films set in Scotland, and films that use Scotland as a film set. Recent years have seen a spate of Hollywood productions that use Glasgow as its canvas in place of other locations. While cities like Vancouver and Budapest have become stand-ins for any number of cities in North America and Europe, Glasgow has found its way onto the list of Hollywood's secret film sets.

As well as serving as a home for slice-of-life comedy, sheer escapism and gritty social realism, Glasgow is in the midst of a boom in film culture. Recent local features like David Mackenzie's *Perfect Sense* (2011) have garnered attention, but a local interest in newer productions like Irvine Welsh's forthcoming *Filth* have become more prominent in the wake of spotlight-drawing productions like *World War Z*, *Cloud Atlas* and *Under the Skin*. Although the latter is alone in this trio as being set in Scotland, the shooting of these big-budget films took place in Glasgow, bringing stars to the city's streets and providing a much needed boost to the local economy.

During the shooting of *World War Z*, half of George Square was barricaded off for seventeen days. Directed by Marc Forster and based on the novel by Max Brooks, the production's 1,200-strong cast and crew included a number of locals, many of whom were non-professional residents who auditioned to play extras roles. Meanwhile Brangelina roamed the streets of the Merchant City as it doubled for a zombie-infested downtown Philadelphia, attracting film tourists to the city. The production dropped off a cheque which has contributed to the production's overall injection of £3.33 million into Glasgow's economy. Glasgow Film Office has estimated a total £5.5 million contribution from *Cloud Atlas*, *Under the Skin*, and BBC's television production *Young James Herriot* combined. All in, a total £20 million was generated by film-making in Glasgow – much of it in the form of Hollywood productions – in 2011.

Similar interest was driven by *Under the Skin*'s Scarlett Johansson, who picked up press coverage as she took her own tour of Glasgow's other offerings, namely (as press clippings would suggest) its bars. No wonder, then, that she later told David Letterman that Glasgow is a 'community of drinkers'. In this case, the film is set in Scotland and shot in a number of locations; the production visited areas like Angus and Glencoe as well as shooting local locations including Celtic Park in Parkhead, Port Glasgow in Renfrewshire, and North Lanarkshire commuter town, Wishaw.

Cloud Atlas, meanwhile, re-dressed the city centre's financial district around Douglas Street as 1970s San Francisco. Its steep hills and unassuming architecture provide the perfect backdrop for the 1970s cars and trucks, which were seen idling in nearby car parks in the south-west corner of the city centre during shooting. As another drop-by production in need of bread and beds, *Cloud Atlas* caused its own mini-frenzy, adding to the economy and providing another

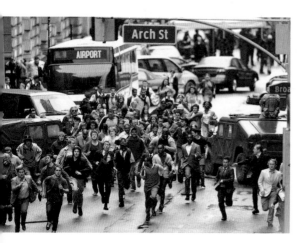

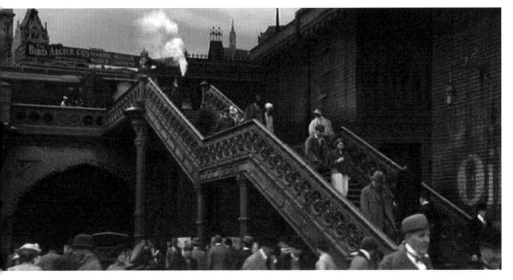

Above © 2000 Arts Council of England, Diaphana Films, FilmFour
Opposite © 2013 Plan B Entertainment, Apparatus Prod., GK Films

excellent opportunity for celebrity-spotting. Halle Berry and Jim Broadbent were spotted out and about but little mention was made of infamously reclusive co-directors and 'Wachowski Brothers' Andy and Lana, who co-direct the film alongside German film-maker Tom Tykwer. Tom Hanks and Susan Sarandon also star in this adaptation of David Mitchell's best-selling novel, which is comprised of six stories set in different times and places. Produced by German studios, it has been billed by the German media as 'the first attempt at a German blockbuster'. Whether its Germanic roots will prevail remains to be seen as the film, with its star-studded cast, will be distributed by Warner Bros. in the United States and Focus Features internationally. Still, Glasgow has in San Francisco another US city to add to its ever-growing résumé alongside Philadelphia (*World War Z*) and New York (*The House of Mirth* [Anderson, 2000]).

As Glasgow proves itself as a versatile location, there is an imbalance inherent in its current film-making industry habits. While big-budget productions drop by for a visit, tour the countryside or dress up the city centre to suit their agendas, the city's home-made

> *World War Z hired some local hands, but lack of infrastructure has left home-grown talent and independent film-makers toiling away on micro-budget films.*

features feel decidedly so. *World War Z* hired some local hands, but lack of infrastructure has left home-grown talent and independent film-makers toiling away on micro-budget films. Similarly, the BBC has shipped its production of *Waterloo Road* away from its namesake and into Dumbartonshire where the local soap opera *River City* is shot and produced.

One successful use of Glasgow as a film set was pulled off by the production of *Unleashed* (aka *Danny the Dog* [2005]) which brought Jet Li and Morgan Freeman to the city as part of a £20 million budget feature – about 20 per cent of which was spent in the United Kingdom. Glasgow Film Office subsidised this production by about £37,000, which enabled the hiring of local crews and services. Citing figures provided by Glasgow Film Office, David Martin-Jones published that 25 locals were hired as crew members, including production and location managers. While the film is hardly replete with Glaswegian voices, it makes reference to the city and is remembered fondly by locals as an esoteric addition to the city's filmography.

At the time of writing, Glasgow needs a push to bring all of these big productions in-house, so to speak, into the heart of Glasgow in order to make the city more than a stop-off point for picking up cheap shots that will see it used as a film set masquerading as different cities. With a little nurturing and more long-term goals, Glasgow can, and will, become a film-making city in its own right. ✛

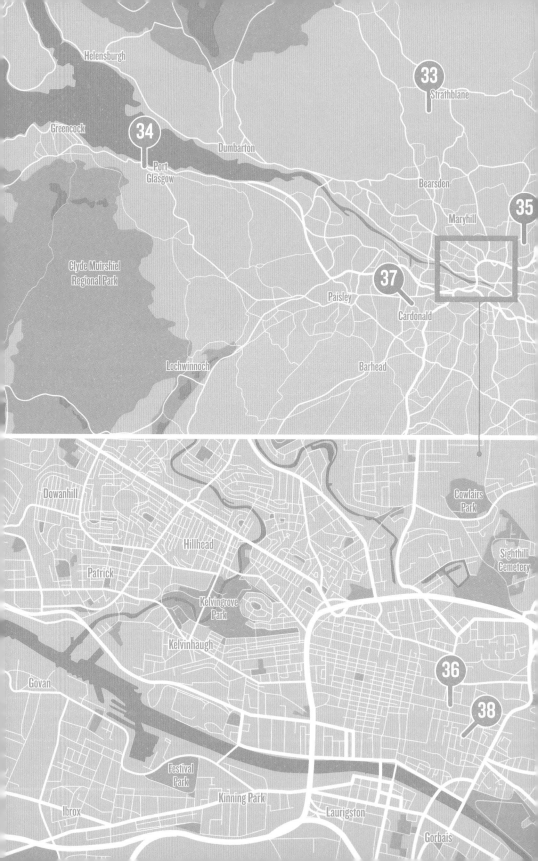

GLASGOW LOCATIONS

SCENES 33-38

maps are only to be taken as approximates

WILD COUNTRY (2005)

LOCATION *Mugdock Castle, Mugdock Country Park, Craigallion Road, Nr. Milngavie, G62 8EL*

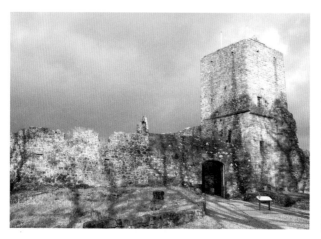

'**THIS IS SAWNEY BEAN COUNTRY,**' remarks Peter Capaldi – in a rather inspired turn as a hypocritical priest – before dropping off a group of teenagers for a wilderness walk in the surroundings of Mugdock Country Park. According to legend, the infamous cannibal's cave was further south at Bennane Head in Ayrshire, but the horror genre rarely concerns itself with factual accuracy. And why should it? The potentially stodgy premise – Kelly Ann, a teenage girl from a council estate, who has been pressured into having her baby daughter adopted – is countered by a supernatural twist. Unexpectedly joined on the hike by her ex-boyfriend (Martin Compston), they discover a baby boy abandoned in the ruins of a castle. More sinister still, the infant is surrounded by dismembered corpses and the group sense they are being followed. The ruins of Mugdock Castle, built in the fourteenth century, provide a suitably spooky exterior. However the scenes inside the castle were filmed on a set built in an abandoned factory in Anniesland for the safety of the young actors. The rather open-ended conclusion and Kelly Ann's dynamic, quick-thinking and mature characterization could be interpreted as an alternative portrayal of an oft-maligned group. However this gruesome caper is perhaps more engaged in reinterpretation, indebted as it is to Doyle's *Hound of the Baskervilles* or the legend of the Beast of Bodmin Moor as well as Sawney Bean. Either way, the film's title hints at something untamed in Scotland's landscape. ••**Susan Robinson**

Photos © Lewis Smith

Directed by Craig Strachan
Scene description: *The teenagers set up camp next to the castle ruins*
Timecode for scene: *0:15:20 – 0:22:50*

Images © 2005 Gabriel Films

NINA'S HEAVENLY DELIGHTS (2006)

LOCATION The Star Hotel, 19 John Wood Street, Port Glasgow, PA14 5HU

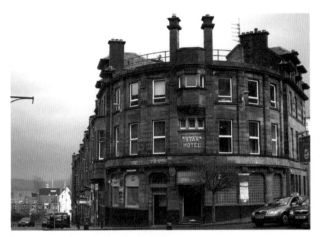

NINA'S HEAVENLY DELIGHTS celebrates the fusion of Scottish and Asian cultures, and presents a community in which integration is commonplace. Central to the creation and communication of this ethos is the use of locations. The film was shot in Port Glasgow over a period of six weeks, with a red brick Victorian building selected as the location of The New Taj restaurant. In actuality, the building is home to The Star Hotel, which was refurbished and transformed into the film's Shah family restaurant, with their home situated directly above. Adjacent buildings were used for other key locations: the florist, run by Elaine C. Smith's character, Auntie Mamie, and the bookies owned by Lisa's (Laura Fraser) father. The close proximity of these locations is conveyed onscreen and communicates to the audience that members of this diverse community are constantly interacting. This is reinforced in the ease with which Mamie and Lisa are shown to enter and leave the Shah family home. This interaction is established from an early point in the film. After the death of her father, Nina (Shelley Conn) returns to Glasgow and The New Taj restaurant, where the Shah family and friends have gathered for her father's wake. In one of many scenes that take place in the kitchen, Lisa, Auntie Mamie, Sanjay (Raji James) and Auntie Tumi (Rita Wolf) are preparing food for the guests. There is a great deal of lively interaction as the characters move freely around the space, coming and going with a great sense of ease in chatty Glaswegian fashion. ➻**Linda Hutcheson**

Photos © Alasdair Watson

Directed by Pratibha Parmar
Scene description: Cooking and chatting in The New Taj kitchen
Timecode for scene: 0:04:43 – 0:06:52

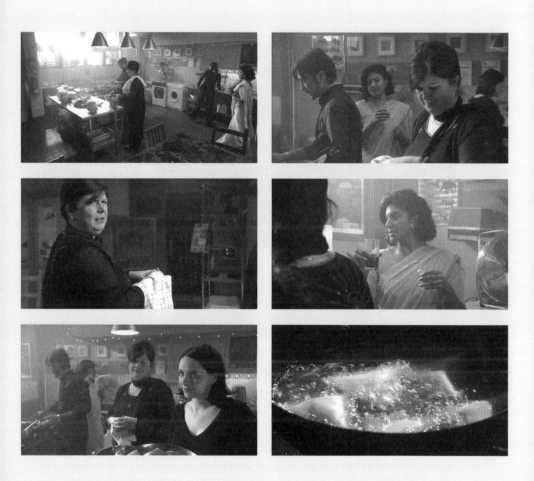

Images © 2006 Kali Films, Priority Pictures, Scottish Screen, Scion Films

RED ROAD (2006)

LOCATION *Red Road Flats, Barnhill, G21*

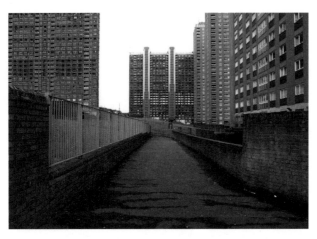

CONCEIVED AS THE FIRST FILM in a planned triptych, *Red Road* is an Advance Party collaboration between Scottish production company Sigma and Lars Von Trier's Dutch Zentropa. Andrea Arnold's powerful debut stars Kate Dickie as Jackie, a lonely CCTV operative who becomes obsessed with Clyde (Tony Curran), a man she recognizes from her past. Tracking him to Barnhill's distinctive and imposing Red Road estate, Jackie gate-crashes a party in Clyde's flat where she meets his friend Stevie (Martin Compston). The next day, she returns to the flat and when she admires the view, Stevie asks her if she wants to 'feel the wind'. When he opens the window, Jackie and April (Natalie Press) are visibly moved backwards by the (obviously real) strength of the wind. There's a lovely moment where all three characters silently admire the 'fucking quality' wind before Stevie ruins it by pretending to push April out the window. Now sadly scheduled for demolition, the eight 31-storey tower blocks comprising Barmulloch's Red Road flats (once the highest residential buildings in Europe) were built between 1964 and 1969, instantly transforming Glasgow's skyline and providing desirable flats for those seeking to avoid the slums. However, by the 1980s, the flats were in decline, falling into disrepair and gaining a reputation for antisocial crime; in the film, the area houses ex-cons. The iconic flats continue to inspire local passions and artistic endeavours with various film-makers and writers seeking to document the (by no means exclusively miserable) experiences of Red Road's one-time residents. ➻**Matthew Turner**

Photos © Lewis Smith

Directed by Andrea Arnold

Scene description: Stevie shows Jackie and April the wind on the top floor of Clyde's Red Road flat
Timecode for scene: 0:56:23 – 1:01:41

Images © 2006 Advance Party Scheme, BBC Films, Glasgow Film Office

DOOMSDAY (2008)

Exterior: Cape Town City Hall, as the fictional St Andrew's Hospital Interior: Glasgow City Chambers, George Square, G1 1DU

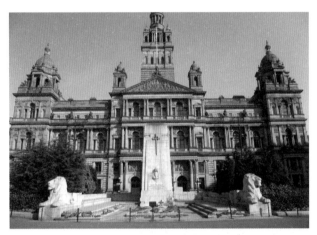

IN THE ANARCHIC *Doomsday* Neil Marshall ingeniously explores Anglo-Scottish tensions through his creation of a diabolical dystopia where the border between the two countries has become a 30-foot, steel-armoured wall, with the Scots callously sealed in to prevent the spread of a fatal epidemic. Twenty-seven years later the deadly disease returns to ravage London, and so the Department of Domestic Security, led by Major Eden Sinclair (Rhona Mitra), are sent into Glasgow (where the virus originated) to extract a cure from those who, against the odds, have survived. As they enter the annihilated city, the team listen to the recorded words of Dr Marcus Kane (Malcolm McDowell) describing the escalating depravity as it happened, 'At night we can hear the distant cries of pain and anguish – they've begun to feed off each other. It's medieval out there.' In this sequence Cape Town doubles for Glasgow city centre, with its Town Hall becoming the fictional St Andrew's hospital. As the team enter the facility the entrance hall featured is that of Glasgow City Chambers, whose walls are pertinently lined with the names of real Glaswegians who died from disease. Doomsday playfully exaggerates the English fear of the more rough-and-ready aspects of Glaswegian culture. Years of brutal, cowardly neglect by the British government have left the few remaining Glaswegians as cannibalistic savages, who – despite their questionable diet and psychotic tendencies – are shown to be robust, resourceful survivors more than capable of taking on English military might.
➠**Emma Simmonds**

Photo right © Kim Traynor / left © Guy Phenix

Directed by Neil Marshall
Scene description: The DDS enter a decimated, seemingly deserted Glasgow
Timecode for scene: 0:27:56 – 0:32:00

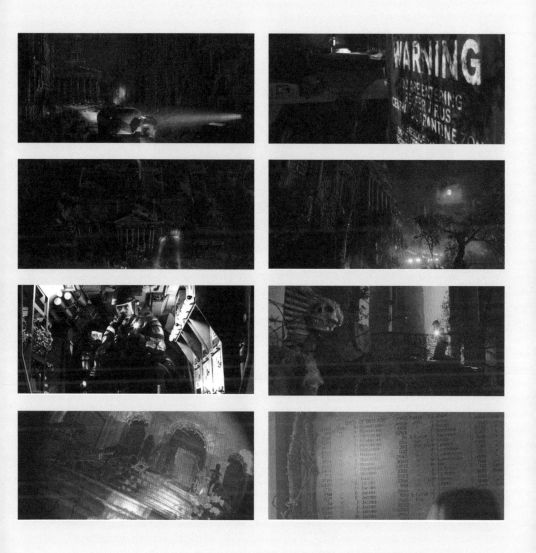

Images © 2008 Rogue Pictures, Intrepid Pictures

NEDS (2011)

LOCATION *Crookston Wood Bridge, Linthaugh Road, Cardonald, G53*

PETER MULLAN'S 'NEDS' (Non-Educated Delinquents), an often harrowing coming-of-age tale peppered with caustic dialogue and brutal violence, draws inspiration from Mullan's troubled upbringing and involvement with the city's Southside street gangs in the early 1970s. With its period fashions, unmistakable Scots brogue and working-class milieu, *Neds* may be time and location specific but its themes are, sadly, timeless and universally familiar. The story of John McGill's (Conor McCarron) descent from a potentially bright academic future into a world of disillusionment, alienation and territorial gang fights is hastened by a dysfunctional family life, economic deprivation and peer pressure. It is a dispiriting scenario too often played out in real life. In one significant scene two rival gangs – one of which includes John and his wayward elder brother Benny (Joe Szula) – stage a mass brawl. Mullan adroitly combines an otherwise nondescript location – Crookston Wood Bridge – with an at-odds soundtrack – The Sensational Alex Harvey Band's version of 'Cheek to Cheek' – to create a violently metaphorical sequence dripping with blood and a blackly comic sensibility. With the gangs occupying separate ends of the bridge, the location acts as a visual metaphor highlighting territorial divides. This is further enhanced by the juxtaposition of the tensions borne of the man-made housing estates being brought into the otherwise sedate, natural surroundings of the wood as mutual loathing erupts into savage violence. With the romantic sentiments of 'Cheek to Cheek' playing over the mayhem that unfolds, Mullan adds a jarring, humorous aural flourish to this brief but striking scene. ◆**Neil Mitchell**

Photos © Lewis Smith

Directed by peter Mullan
Scene description: Dancing cheek to cheek
Timecode for scene: 0:55:16 – 0:57:20

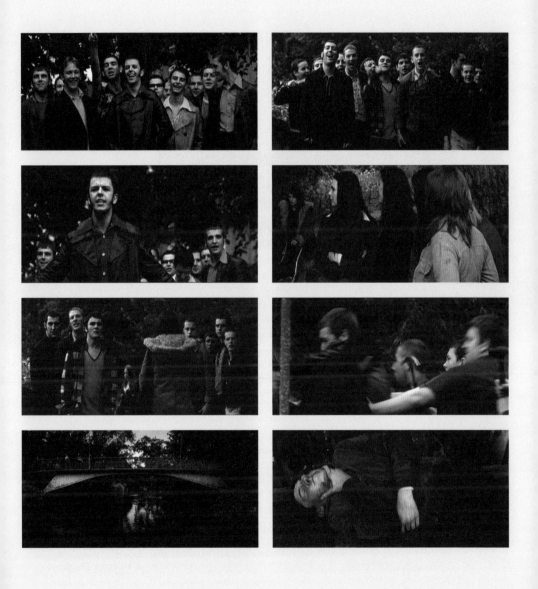

Images © 2011 Blue Light, StudioUrania, Fidélité Films

PERFECT SENSE (2011)

LOCATION *Corner of Wilson and Brunswick Street, Merchant City, G1*

PERFECT SENSE IS AN UNUSUAL and occasionally surprising indie sci-fi film, which chronicles the blossoming romance of two young lovers as the world crashes around them. Reflecting a recent appetite for ambitious science fiction juxtaposed with muted human drama (see also: *Melancholia* [Von Trier, 2011], *Another Earth* [Cahill, 2011]), the film imagines a reality where humanity loses each sense one-by-one, accompanied by involuntary and distressing side effects. Gourmet chef Michael (Ewan MacGregor, here reunited with *Young Adam* (2003) director David Mackenzie), falls for scientist Susan (Eva Green) just as the human race appears to have its days numbered. Glasgow is our window into this universal, unstoppable phenomenon, and by the time we have lost three senses in succession (smell, taste and hearing), the world starts to panic. The streets of Glasgow that we saw earlier – the well-kept cosmopolitan shops, bars and restaurants of Merchant City – are transformed into a post-apocalyptic nightmare. Looters smash windows and raid shops. Cars and buses lie abandoned. Rubbish is strewn about the streets. Yet, as the unseen narrator ponders, 'life goes on.' Faced with the near-hopeless challenge of selling fine food to a public who can no longer taste how good it is, Michael's restaurant gives precedence to texture and temperature over flavour. The world adapts, adjusts, and survives. Mackenzie's outlook on our species is fundamentally optimistic, and his film taps into a singularly Glaswegian stoicism, present even in the face of annihilation. ◦➤**John Nugent**

Photo © Lewis Smith

Directed by David Mackenzie
Scene description: Looters raid a shop in post-apocalyptic streets
Timecode for scene: 1:10:35 – 1:13:35

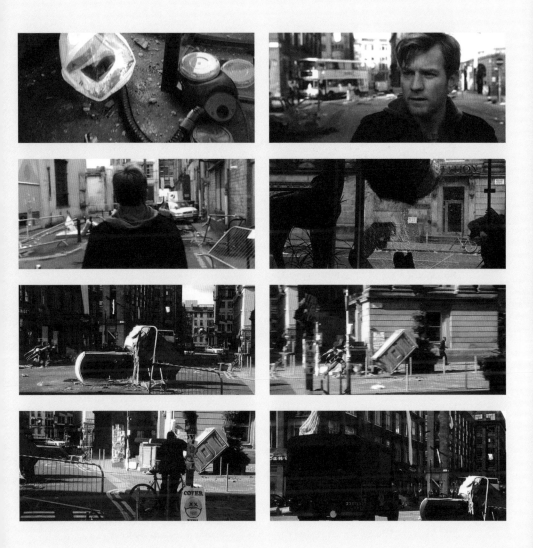

Images © 2011 Sigma Films

GO FURTHER

Recommended reading and useful websites

BOOKS

Scotland: The Movie
by David Bruce
(Polygon, 1996)

Cinema and Cinema-going in Scotland, 1896–1950
by Trevor Griffiths
(Edinburgh University Press, 2012)

Scotland in Film
by Forsyth Hardy
(Edinburgh University Press, 1990)

Cinema at the Periphery
by Dina Iordanova, David Martin-Jones
and Belén Vidal
(Detroit: Wayne State University Press, 2010)

Scotch Reels:
Scotland in Cinema and Television
by Colin McArthur
(BFI Publishing, 1982)

Scotland: Global Cinema
by David Martin-Jones
(Edinburgh University Press, 2009)

Discomfort and Joy:
The Cinema of Bill Forsyth
by Jonathan Murray
(Peter Lang, 2012)

100 Years of Glasgow's Amazing Cinemas
by Bruce Peter
(Polygon, 1996)

Screening Scotland
by Duncan Petrie
(BFI Publishing, 2000)

BOOKS (CONTINUED)

Cinema City:
Glasgow and the Silver Screen
by Neil Johnson-Symington
(RIAS Millennium Awards, 2004)

ONLINE

Creative Scotland Locations
http://locations.creativescotland.com/

Glasgow Film Office
http://glasgowfilm.com

Glasgow Film: Cinema City
http://glasgowfilm.org/cinema_city

Scotland: The Movie Location Guide
http://www.scotlandthemovie.com/

Scotland's Surviving Cinemas
http://www.scottishcinemas.org.uk/index.html

Sigma's Advance Party Initiative
http://www.sigmafilms.com/films/advance-party-ii/

'A Quick Chat with Lucas Belvaux'
Stuart Henderson
http://www.kamera.co.uk/interviews/a_quick_chat_with_lucas_belvaux.php)

'The Times BFI London Film Festival Preview: Mean Streets'
by Hannah McGill
(Sight & Sound, November 2006)
http://www.bfi.org.uk/sightandsound/feature/49329

CONTRIBUTORS

Editor and contributing writer biographies

EDITOR

NICOLA BALKIND is a writer and digital freelancer based in Glasgow. She contributes to a number of volumes in the World Film Locations series as well as BBC Radio Scotland's *Movie Café* and regional press. You can find Nicola online at http://nicolabalkind.com and on Twitter @robotnic.

CONTRIBUTORS

DAVID ARCHIBALD is Lecturer in Film and Television Studies at the University of Glasgow where he is Convenor of their Film Journalism Masters programme. His monograph on the Spanish Civil War in Cinema will be published by Manchester University Press in 2012.

JEZ CONOLLY holds an MA in Film Studies and European Cinema from the University of the West of England, is a regular contributor to *The Big Picture* magazine and website, and has co-edited the Dublin and Reykjavík volumes in the World Film Locations series with Caroline Whelan. His book, *Beached Margin: The role and representation of the seaside resort in British films*, was published in 2008. He is currently working on *World Film Locations: Liverpool* and a monograph about John Carpenter's *The Thing*. In his spare time he is the Arts and Social Sciences & Law Faculty Librarian at the University of Bristol.

HELEN COX is Editor in Chief of New Empress Film Magazine and author of *True Love is Like the Loch Ness Monster and Other Lessons I Learnt From Film*. After qualifying for her MA in Creative Writing she moved from Yorkshire to London to pursue a career in film journalism. She has since written for publications such as *The Guardian*, *The Spectator* and *Lost in the Multiplex*, she's also learnt facts about titles such as *St Elmo's Fire* and *Howard the Duck* that nobody should rightly know. Should she ever be forced onto an episode of *Mastermind*, *Grease 2* would be her specialism. More information about Helen's projects can be found at www.helenography.net. She also lives on Twitter @helenography.

JAMIE DUNN is a freelance film journalist and film editor of *The Skinny*, Scotland's most widely read arts and culture magazine. He also contributes programme notes to Glasgow Film Theatre's learning team and occasionally reviews films on BBC Radio Scotland's *Movie Café*. From 2009 to 2011, he co-hosted a weekly film-based radio programme called *Screen Shrapnel*, broadcast out of online radio station Subcity, in Glasgow. His favourite film-maker is Brian De Palma and he'll fight anyone who has a bad word to say about the baroque genius. You can read Jamie's thoughts on film on Twitter @jamiedunnesq.

PAUL GALLAGHER is a Glasgow-based film critic, writing for *The List* magazine and contributing regular reviews and opinions on BBC Radio Scotland's *Movie Café*. He can be found on Twitter @paulcgallagher.

PAUL GREENWOOD is the film critic for the *Glasgow Evening Times*.

SCOTT JORDAN HARRIS writes for *The Telegraph* and was former editor of *The Spectator*'s arts blog. He is also the editor of several volumes in the World Film Locations series and was editor of *The Big Picture* magazine from 2009–11 before being promoted to Senior Editor. He writes a sports blog for *The Huffington Post* and his work has been published in several books and by, among others, the BBC, *The Guardian*, *Fangoria*, *Rugby World*, *Film4.com*, *Scope*, *movieScope* and *Film International*. Roger Ebert lists @ScottFilmCritic as one of the top 50 'movie people' to follow on Twitter and featured Scott in his article 'The Golden ➜

CONTRIBUTORS

Editor and contributing writer biographies (continued)

Age of Movie Critics' as one of the critics he believes is doing most to contribute to that golden age. In 2010, *Running in Heels* named Scott's blog, *A Petrified Fountain* (http://apetrifiedfountain. blogspot.com), as one of the world's twelve 'best movie blogs' alongside */Film, Kermode Uncut* and *Roger Ebert's Journal.*

KEIR HIND edits for and is a contributing writer to the Books section of *The Skinny Magazine.* He also helps compile and present the monthly Film Quiz at the GFT.

LINDA HUTCHESON is a doctoral student at the University of Stirling. Her thesis examines contemporary Scottish cinema, focusing in particular on the Scottish-Danish Advance Party Initiative. Her research interests include Scottish and British cinema, with specific interests in national and transnational film theory, film marketing and the process of film production.

PASQUALE IANNONE is an academic, broadcaster and curator based in Edinburgh. He holds a Ph.D. from the University of Edinburgh where he is currently Lecturer in Film Studies and Course Organiser for Introduction to European Cinema. His research interests include European film history and theory (Italian and French cinema in particular), film aesthetics (especially sound and music) and filmic representations of childhood. Pasquale has written for journals such as *Sight & Sound, Senses of Cinema, Little White Lies* and *The List* and has ten years broadcasting experience, contributing regularly to BBC Radio 4's *The Film Programme* and BBC Radio Scotland's *Movie Café.* He has also been the *Movie Café*'s regular guest presenter since 2008. His film curation work includes seasons at Edinburgh's Filmhouse and Glasgow Film Theatre. You can follow Pasquale on Twitter: @pasqualeiannone.

SIMON KINNEAR (@kinnemaniac) is a freelance film journalist. He is a regular reviewer and feature writer for *Total Film*, and has also written for *SFX, Doctor Who Magazine* and *Clothes on Film.* He introduces film screenings at Derby QUAD and writes a movie blog, www. kinnemaniac.com. In addition to this volume of World Film Locations, he has contributed to the New York and New Orleans editions.

NEIL MITCHELL is a writer and editor based in Brighton, East Sussex. He is the editor of the London and Melbourne editions of the World Film Locations series and the co-editor of the Britain edition of the Directory of World Cinema series, also for Intellect Books. He writes for *The Big Picture, Electric Sheep, Little White Lies* and *Eye For Film.* At the time of writing, he is working on a monograph on Brian De Palma's *Carrie* for Auteur Publishing.

JOHN NUGENT is a London-based writer and journalist, specializing in film and the arts. He graduated from the University of Kent with a BA (Hons) in Film Studies and Philosophy, and has written film reviews and features for a variety of publications in print and online. He was also selected as the resident weekly columnist for arts charity IdeasTap. He particularly enjoys the films of Buster Keaton, Paul Thomas Anderson and Pixar, and is not ashamed to admit he doesn't like *Star Wars.* He maintains a poorly-read blog at www.thenuge.co.uk.

SUSAN ROBINSON (@SusanGRob) does not have a degree in film and she doesn't live in Glasgow. However she did study English Literature at the University of Edinburgh and has written for the 'Edinburgh International Film Festival' website. She also works for Edinburgh UNESCO City of Literature and has a cat called Saffron.

EMMA SIMMONDS is a London-based freelance journalist, editor and copywriter specializing in film and TV. She graduated in 2003 from the University of Kent with a BA (Hons) in Film Studies, and went on to complete a BFI/Sight and Sound Postgraduate Certificate in Film Journalism in 2005 for which she received a merit. Her words have since appeared in *The Guardian*, *Time Out*, *Little White Lies*, *theartsdesk*, *The Spectator* and *PopMatters*, amongst many others. She blogs as *The Perpetual Picturehouse* and is also a contributor to the London and New York volumes in the World Film Locations book series.

LEWIS SMITH is a freelance photographer and writer. Originally from Wishaw, he is a graduate of both the University of Aberdeen and the University of Glasgow. He is currently working on an ongoing project to document derelict and repurposed cinema buildings across Scotland. He can be contacted at lewis.hamilton.smith@gmail.com.

NEIL JOHNSON-SYMINGTON's interest in Glasgow on screen started many years ago as a 10 year old watching *Gregory's Girl*. Since then he has studied art, literature and film at Edinburgh University, gaining his postgraduate degree at Goldsmiths College, London. Based in Glasgow, he is a curator and writer specializing in film and cultural history, having developed exhibitions for the National Maritime Museum, London; Summerlee Heritage Museum, Coatbridge; and the Design Museum, London, where he co-curated the United Kingdom's first retrospective of the film work of designer Saul Bass. In 2004 Neil wrote *Cinema City: Glasgow and the Silver Screen* and his exploration of the subject has since continued with displays curated for Glasgow's Lighthouse Centre for Design and Riverside Museum of Transport; published articles for Glasgow City Marketing Bureau and Glasgow Film Theatre; and classes for Strathclyde University. Find out more at www.nrsconcepts.co.uk.

MATTHEW TURNER, a lifelong film fanatic, has been the film reviewer for *ViewLondon.co.uk* since its launch in 2000. As a freelancer he has written for *Empire*, *Total Film*, *Hotdog*, *FilmStar*, *MyMovies*, *WHSmithonline*, *What's On* and *The List*, as well as several interviews for *The Big Issue*. He's also written various part work magazine features, contributed over 1,000 questions to an online film quiz, and spent a year as a scriptwriter and researcher on a film review TV show called *Get the Picture* for Carlton Cinema. His favourite film is *Vertigo* and he lives in Ealing.

SEAN WELSH is a freelance film journalist. He blogged officially for 'Glasgow Film Festival' (2011 and 2012), for *The List* at the 'Edinburgh Film Festival 2011', and regularly writes programme notes for Glasgow Film Theatre. He has contributed to Martin C. Strong's *Lights, Camera, Soundtracks* (Canongate), and writes about film at http://physicalimpossibility.wordpress.com. As part of Matchbox Cineclub, he promotes feature and short film programmes in venues across Glasgow.

CAROLINE WHELAN is a freelance writer, researcher and creative writing student. A big fan of films and Glasgow, she co-edited *World Film Locations: Dublin* with Jez Conolly.

FILMOGRAPHY

All films mentioned or featured in this book